Bento's Sketchbook

Bento's Sketchbook

John Berger

PANTHEON BOOKS, NEW YORK

Pantheon Books and colophon are registered
trademarks of Random House, Inc.

Library of Congress Cataloging-in-Publication Data
Berger, John.
Bento's sketchbook / John Berger.
p. cm.
ISBN 978-0-307-37995-5
1. Berger, John—Themes, motives. 2. Drawing—Philosophy.
3. Spinoza, Benedictus de, 1632–1677—Miscellanea. I. Title.
NC242.B47A4 2011 741.942—dc22 2011010841

www.pantheonbooks.com
Jacket design by Peter Mendelsund
Printed in the United States of America
First American Edition
2 4 6 8 9 7 5 3 1

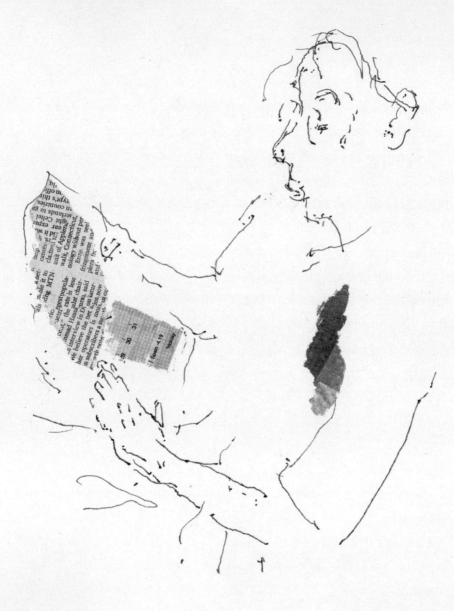

Beverly reading

This autumn the quetsch plum trees are overburdened with fruit. Some have branches that have snapped under the weight. I can't recall another year when there were so many plums.

When ripe those purple plums acquire a bloom the colour of dusk. At midday if there's sunlight – and it has been sunny for days on end – you see clusters of them, the colour of dusk, hanging behind the leaves.

Blueberries are the only other fruit which are as blue, but their blue is dark and gemlike, whereas the quetsch blue is like a vivid but vanishing blue smoke. The clusters of four, five or six fruit grow like handfuls from small shoots of the trees' branches. From a single tree hang hundreds of handfuls.

Early one morning I decide to draw a cluster, perhaps to understand better why I repeatedly say 'handful'. The drawing was clumsy and bad. I begin another. Three handfuls away from the one I have chosen to draw, a small black and white snail, small as my fingernail, is asleep on the leaf it has been eating. The second drawing was as bad as the first. So I stopped and began the day's tasks.

Towards the end of the afternoon I returned to the plum trees with the idea of trying, one more time, to draw the same cluster. Perhaps due to the change of light – the sun was no longer in the east but the west – I could not find or identify the cluster. I even asked myself whether I was under the right tree.

I moved over to the next tree, stooping under its branches, peering up. There were countless quetsch but not my handful. It would of course have been easy to draw another cluster but something in me obstinately refused. I circled under the branches of both trees again and again. And then I spotted the snail. Thirty centimetres to his left I found my cluster. The snail had changed his position but not his whereabouts. I took a good look at him.

I began to draw. I needed a green to mark the leaves. At my feet were some nettles. I picked a leaf, rubbed it on the paper, and it gave me a green. This time I kept the drawing.

Three days afterwards it was time to harvest the plums. If put in barrels to ferment for a few months, you can distil an excellent slivovitz from them. They also make good jam and are wonderful on tarts.

To harvest quetsch you either shake the tree's boughs and many plums fall to the ground, or you climb up into the tree with a bucket and pick them by hand.

The trees have incipient thorns and a multitude of twigs. High in the tree, you have the sensation of crawling through under-growth, proceeding from one small blue smoke ring to another, and gathering in the palm of your free hand, warm thumb after warm thumb. You can hold three or four, or five, not more. This is why I call the clusters handfuls. Inevitably some of the fruit roll down your wrist and fall to the grass.

When I was later on my knees picking up plums from the grass and dropping them into a basket, I came across several black and white snails, who had fallen unhurt to the ground with the fruit. I placed five of them side by side, and to my surprise it was easy for me to recognise the one who had been my guide. I made a drawing of him, a little over life-size.

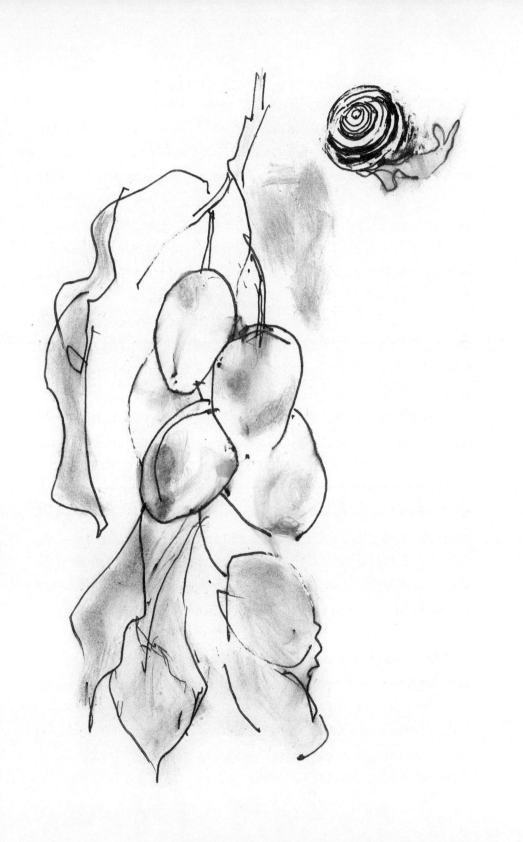

The philosopher Baruch Spinoza (1632–1677) – generally known as Benedict (or Bento) de Spinoza – earnt his living as a lens-grinder and spent the most intense years of his short life writing *On the Improvement of the Understanding* and the *Ethics*, both of which were only published posthumously. We know from other peoples' souvenirs and memories of the philosopher that he also drew. He enjoyed drawing. He carried a sketchbook around with him. After his sudden death – perhaps from silicosis, a consequence of his grinding lenses – his friends rescued letters, manuscripts, notes, but apparently didn't find a sketchbook. Or, if they did, it later got lost.

For years now, I have imagined a sketchbook with his drawings in it being found. I didn't know what I hoped to find in it. Drawings of what? Drawn in what kind of manner? De Hooch, Vermeer, Jan Steen, Gerard Dou were his contemporaries. For a while in Amsterdam he lived a few hundred metres away from Rembrandt, who was twenty-six years his elder. Biographers suggest the two of them probably met. As a draughtsman Spinoza would have been an amateur. I wasn't expecting great drawings in the sketchbook, were it to be found. I simply wanted to reread some of his words, some of his startling propositions as a philosopher, whilst at the same time being able to look at things he had observed with his own eyes.

Then last year a Polish printer, who is a friend of mine living in Bavaria, gave me a virgin sketchbook, covered with suede

leather, the colour of skin. And I heard myself saying: This is Bento's!

I began to make drawings prompted by something asking to be drawn.

As time goes by, however, the two of us – Bento and I – become less distinct. Within the act of looking, the act of questioning with our eyes, we become somewhat interchangeable. And this happens, I guess, because of a shared awareness about where and to what the practice of drawing can lead.

Diagram by Spinoza of telescope lenses and eye.

I'm drawing some irises which are growing against the south wall of a house. They are about one metre tall, but, beginning to be in full bloom, they are somewhat bent over by the weight of their flowers. Four to a stalk. The sun is shining. It's the month of May. All the snow at altitudes less than 1500m has melted.

I think these irises are of a variety called Copper Lustre. Their colours are dark crimson-brown, yellow, white, copper: the colours of the instruments of a brass band being played with abandon. Their stalks and calyxes and sepals are a pale viridian.

I'm drawing with black ink (Sheaffer) and wash and spit, using my finger rather than a brush. Beside me on the grass, where I'm sitting, are a few sheets of coloured Chinese rice paper. I chose them for their cereal colours. Maybe later I will tear shapes from them and use them as collage. I have a glue-stick if need be. There's also on the grass a bright yellow oil pastel, taken from a pastel kit made for schoolkids with the trade-name Giotto.

The drawn flowers look as though they're going to be half life-size. You lose your sense of time when drawing. You are so concentrated on scales of space. I've probably been drawing for about forty minutes, perhaps longer.

Irises grew in Babylon. Their name came later, from the Greek goddess of the rainbow. The French *fleur de lys* was an iris. The blossoms occupy the top half of the paper, the stems force their

way upwards through the bottom half. The stems are not vertical, they lean to the right.

At a certain moment, if you don't decide to abandon a drawing in order to begin another, the looking involved in what you are measuring and summoning up changes.

At first you question the model (the seven irises) in order to discover lines, shapes, tones that you can trace on the paper. The drawing accumulates the answers. Also, of course, it accumulates corrections, after further questioning of the first answers. Drawing is correcting. I'm beginning now to use the Chinese papers; they turn the ink-lines into veins.

At a certain moment – if you're lucky – the accumulation becomes an image – that's to say it stops being a heap of signs and becomes a presence. Uncouth, but a presence. This is when your looking changes. You start questioning the presence as much as the model.

How is it asking to be altered so as to become less uncouth? You stare at the drawing and repeatedly glance at the seven irises to look, not at their structure this time, but at what is radiating from them, at their energy. How do they interact with the air around them, with the sunshine, with the warmth reflected off the wall of the house?

Drawing now involves subtracting as much as adding. It involves the paper as much as the forms drawn on it. I use razor blade, pencil, yellow crayon, spit. I can't hurry.

I'm taking my time, as if I had all the time in the world. I do have all the time in the world. And with this belief I continue making the minimal corrections, one after another and then another, in order to make the presence of the seven irises a little more comfortable and so more evident. All the time in the world.

In fact I have to deliver the drawing tonight. I have made it for Marie-Claude, who died two days ago, aged fifty-eight, of a heart attack.

Tonight the drawing will be in the church somewhere near her coffin. The coffin will be open for those who want to see Marie-Claude for the last time.

Her funeral is tomorrow. Then the drawing, rolled up and tied with a ribbon, will be placed with live flowers in her coffin and be buried with her.

We who draw do so not only to make something visible to others, but also to accompany something invisible to its incalculable destination.

Two days after Marie-Claude's funeral I received an email telling that a small drawing of mine – an eighth of the size of the drawing of the Copper Lustre irises – had been sold in a London art auction for £4,500. A sum of money such as Marie-Claude would never have dreamt of having in her hands during her entire lifetime.

The auction was organised by the Helen Bamber Foundation, which gives moral, material and legal support to people begging for asylum in Great Britain, people whose lives and identities have been shattered by traffickers of immigrants – slave traders in all but name – by armies that terrorise civilian populations, and by racist governments. The Foundation appealed to artists to donate a work which could be sold to raise funds for its activities.

Along with many others I sent a small contribution: a little portrait in charcoal of the Subcomandante Marcos which I had made in the Chiapas, southeast Mexico, around Christmas 2007.

He, I, two Zapatista comandantes and two children are taking

it easy in a log cabin on the outskirts of the town of San Cristóbal de Las Casas.

We've written letters to each other, Marcos and I, we've spoken together from the same platform, but we've never before sat face to face in private. He knows I'd like to draw him. I know he won't take off his mask. We could talk about the forthcoming Mexican elections or about peasants as a class of survivors and we don't. A strange quietude affects us both. We smile. I watch him and I have no sense of urgency about drawing him. It's as if we've spent countless days together, as if everything is unremarkably familiar and requires no action.

Finally I open my sketchbook and pick up a stick of charcoal. I see his low brow, his two eyes, the bridge of his nose. The rest is concealed by ski-mask and cap. I let the charcoal, held between my thumb and two fingers, draw, as if reading by touch some kind of braille. The drawing stops. I blow fixative onto it so it won't smudge. The log cabin smells of the alcohol of the fixative.

In the second drawing his right hand comes up to touch the cheek of his mask, a large hand splayed out, with pain between its fingers. The pain of solitude. The solitude of an entire people over the last half millennium.

Later a third drawing starts. Two eyes examining me. The presumed undulation of a smile. He is smoking his pipe.

Smoking a pipe, or watching a companion smoking a pipe, is another way of letting time pass, of doing nothing.

I fix the drawing. The next drawing, the fourth, is about two men looking hard at one another. Each in his own manner.

Maybe the four are not proper drawings but simply sketch maps of an encounter. Maps that may make it less likely to get lost. A question of hope.

It was one of these maps that I gave to the Helen Bamber Foundation.

Apparently the bidding for it was prolonged and fierce. The bidders were competing to give money to a cause in which they believed, and, in exchange, they hoped to get a little closer to a visionary political thinker, sheltering in the mountains of southeast Mexico.

The money the drawing fetched at the auction will help to buy medicines, care, counsellors, nurses, lawyers for Sara or Hamid or Gulsen or Xin . . .

We who draw do so not only to make something observed visible to others, but also to accompany something invisible to its incalculable destination.

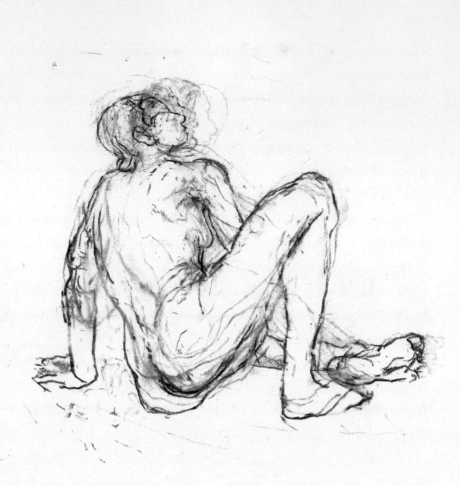

Now, a drawing I started two weeks ago, and every day since then I've worked on it, crept up on it to take it unawares, corrected it, erased it – it's a large charcoal drawing on thick paper – hidden it away, displayed it, reworked it, looked at it in a mirror, redrawn it, and today I think it's over.

It's a drawing of Maria Muñoz, the Spanish dancer. In 1989, with Pep Ramis, the father of their three children, Maria founded a dance company called Mal Pelo. They work in Girona in Catalonia and perform in numerous European cities. Five years ago they invited me to collaborate with them.

Collaborate how? I'd watch them for hours improvising and

rehearsing, singly, together, in couples. And sometimes I'd suggest a twist in the story-line or a word or two or an image that might be projected. They could use me as a kind of narrative clock.

I watched them preparing meals, talking round a table, comforting children, mending a chair, changing clothes, exercising and dancing. Maria was, by far, the most experienced dancer, but she did not direct. Rather she set an example, often by showing how to take risks.

The bodies of dancers with their kind of devotion are dual. And this is visible whatever they are doing. A kind of Uncertainty Principle determines them; instead of being alternately particle and wave, their bodies are alternately giver and gift.

They know their own bodies in such a penetrating way that they can be within them, or before them and beyond them. And this alternates, sometimes changing every few seconds, sometimes every few minutes.

The duality of each body is what allows them, when they perform, to merge into a single entity. They lean against, lift, carry, roll over, separate from, co-join, buttress each other so that two or three bodies become a single dwelling, like a living cell is a dwelling for its molecules and messengers, or a forest for its animals.

The same duality explains why they are as much intrigued by falling as by leaping, and why the ground challenges them as much as the air.

I write this about the company, Mal Pelo, performing, because it's a way of describing Maria's body.

One day watching her, I started to think about the late Degas bronzes and drawings of nude dancers and, in particular, one

called *Spanish Dance*. I asked Maria if she would pose for me. She agreed.

Let me show you something, she suggested, it's a preparatory position we take on the floor and we call it the Bridge, because our weight is suspended between our left hand palm down on the floor and our right foot also flat on the floor. Between those two fixed points the whole body is expectant, waiting, suspended.

Drawing Maria in the Bridge position was like drawing a coal miner working in a very narrow seam. Maria's body was highly feminine, but what was comparable was its visible experience of exertion and endurance.

Its duality was evident in its calm – her relaxed left foot lay on the floor like an animal asleep – and in the grid of forces in her hips and back ready to challenge every dead weight.

Finally we stopped. She came to look at the drawing. We laughed together.

Then the days of working at home on it. The image in my head was often clearer than the one on the paper. I redrew and redrew. The paper became grey with alterations and cancelations. The drawing didn't get better, but gradually she, about to stand up, was more insistently there.

And today, like I said, something has happened. The effort of my corrections and the endurance of the paper have begun to resemble the resilience of Maria's own body. The surface of the drawing – its skin, not its image – make me think of how there are moments when a dancer can make your hairs stand on end.

We who draw do so not only to make something observed visible to others, but also to accompany something invisible to its incalculable destination.

We sense and experience that we are eternal. For the mind no less senses those things which it conceives in understanding than those which it has in the memory. For the eyes of the mind by which it sees things and observes them are proofs. So although we do not remember that we existed before the body, we sense nevertheless that our mind in so far as it involves the essence of the body under a species of eternity is eternal and its existence cannot be defined by time or explained by duration.

<div style="text-align: right">(Spinoza, Ethics, Part V, Proposition XXIII)</div>

Devorah teaches philosophy at London University and is a follower of Spinoza. I asked if she would sit for me so that I might draw her. I've never been drawn! she replied. And then she started talking, questioning, wondering, and I drew her.

The mind, in so far as it has both clear and distinct and confused ideas, endeavours to persist in its being for an indefinite period, and is conscious of this its endeavour.

(*Ethics*, Part III, Proposition IX)

By hearsay alone I know my birthday, and the fact that I had such and such parents, and similar things of which I have never doubted. By uncertain experience I know that I shall die; for I affirm this on the grounds that I have seen others like me die, even though they did not all live for the same length of time, or die of the same disease. Again, I also know by uncertain experience that oil is suitable for feeding a flame, and water for extinguishing it. I know, too, that the dog is an animal that barks, and that man is a rational animal; and in this way I have got to know nearly everything that is of use in life. We infer one thing from another in the following way: after we perceive clearly that we sense such and such a body and no other, from this (I say) we infer clearly that the soul is united to the body – a union which is the cause of this sensation. But what this sensation and this union are, we cannot absolutely understand from this.

(*Treatise on the Correction of the Intellect*, Paragraph 20)

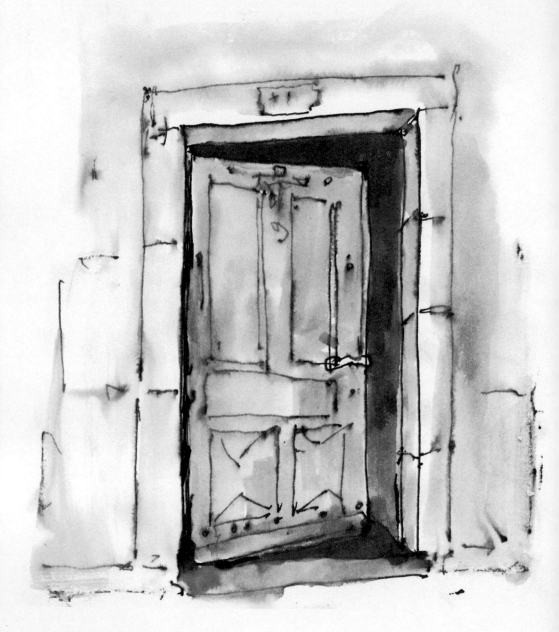

It began like this.

It began like this. About ten years ago, Nella was in Moscow, staying with some old Russian friends. One day she passed a junk shop. Maybe it considered itself an antique shop. People at that time in Moscow were selling whatever they could find in their cupboards because wages and pensions had collapsed. One could buy family silver on street corners. For Nella, second-hand shops in any city in the world are as irresistible as dictionaries. She goes in to turn the pages. This time she found a painting. Oil on canvas. A small still-life of some red chrysanthemums.

She bought it. Signed and dated: Kleber, 1922. It cost less than a song. Far less.

Back in Paris she didn't know where to hang it. It looked right nowhere. Here and there little flakes of paint – the size of salt grains – had fallen off, and you could see the white of the canvas. When in doubt Nella waits for the doubt to disappear. It usually does. She put the canvas in a black plastic sack in the garage alongside other packages of clothes, books and nondescript objects forgotten by those passing through. Before hiding it away she showed it to me, and I thought: Flowers in a nineteenth-century interior, with no hint of change, could only be Russian. The chrysanthemums were lying on a narrow ledge. Behind them stood an empty glazed vase. Were they about to be arranged in this pot? Or had they been taken out, a little too early, to be thrown away? In either case, better to leave it in the garage.

Time passed. One year the garage got flooded. Nella took the painting out of its sack and propped it up in various corners of the lived-in rooms. More paint had flaked off, leaving more spots of white canvas. The damage was by now far more arresting than the image.

I can't bring myself to throw it away, Nella said last week.

I found myself replying: I'll try to repair it. It can't be restored properly, it's too far gone and I don't have the skill. I can just colour the white spots.

So I started. Mixing the colours on a white saucer. For many years I hadn't used oil paint. When drawing I use inks or acrylic. No other colours mix like oil colours. You search touch by touch for a timbre on the saucer and then you discover whether or not, when applied to the canvas, the colour matches the 'voice' you were searching for.

There were hundreds of white flaked-off spots to cover. Blackish crimsons for the flowers in shadow. Guitar browns for the wood of the drawer under the ledge. Shellfish greys for the walls in the corner where the ledge was. An indescribable magenta pink for the petals in the light. Everything suggested the room was small, with probably, in 1922, many people living in it.

I lost count of time as I covered white spot after white spot. With this loss of a sense of time, my sense of identity slackened. Touch by touch, tone by tone, I was approaching a systematic vision which belonged to a pair of eyes which until then were not mine. These eyes were in another place.

I was observing flowers thrown on a ledge in the corner of a small room in the afternoon light of a late September day in the year 1922. The Civil War was over. It was nevertheless a year of widespread famine. Nearly all the white spots are now covered.

I went to look at the painting several times during the night. Or rather to look at the painted corner in the small room. I couldn't leave them like that. Neither the flowers on the ledge nor the painting. You could still see where the white spots had been. Pockmarked. I had to return them in better condition to that late September afternoon, before the dreaded cold of winter arrived.

I needed to paint more freely. Yet I could not treat the painting as mine; it was Kleber's. More thoroughly his than I could have previously imagined. If I wasn't free, the light wouldn't come back.

The next day early in the morning I continued. Sitting with the canvas on my knees and the saucer on the table beside me. There are some lines in a poem by Akhmatova on the theme of mourning which refer to a chrysanthemum crushed by a boot on a sidewalk. These lines were written twenty years later. The crimson chrysanthemums in this still-life are still innocent.

I paint freely, inspired by the longing of what is there on the canvas. I discover how in the corner of a small room the light, falling on two peeling walls and half a dozen thrown-down flowers, is a kind of promise from some distant, unimaginable future.

The job is done. There it is, a painting by Kleber, 1922.

A moment has, for a moment, been saved. This moment occurred before I was born. Is it possible to send promises backwards?

As long as a man is affected by the image of anything, he regards the thing as present, although it may not exist, nor will he regard it as past or future save in so far as its image is connected with the image of time past or future. Wherefore the image of the thing considered in itself is the same whether it refers to time present, past, or future, that is the constitution of the body, or, the emotion is the same whether the image of the thing be present, past, or future. And so the emotion of pleasure or pain is the same whether the image of the thing be present, past, or future.

(*Ethics*, Part III, Proposition XVIII, Proof)

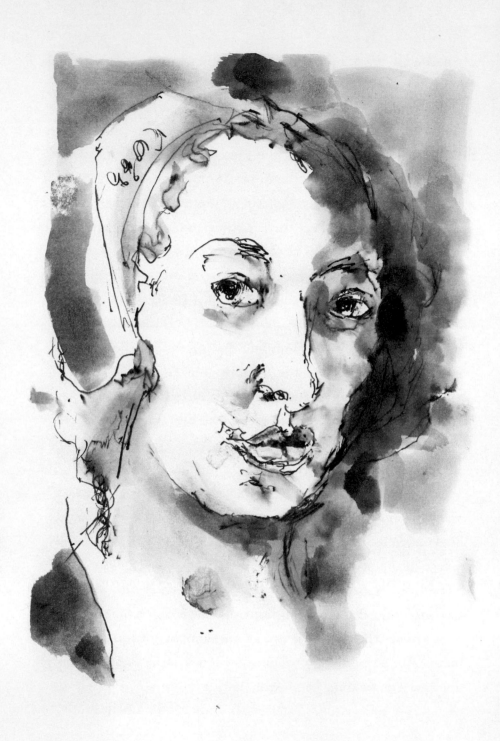

From a Woman's Portrait by Wilhem Drost.

A house stands on one side of a square in which there are tall poplars. The house, built just before the French Revolution, is older than the trees. It contains a collection of furniture, paintings, porcelain, armour which, for over a century, has been open to the public as a museum. The entry is free, there are no tickets, anybody can enter.

The rooms on the ground floor and up the grand staircase, on the first floor, are all the same as they were when the famous collector first opened his house to the nation. As you walk through them, something of the preceding eighteenth century settles lightly on your skin like powder. Like eighteenth-century talc.

Many of the paintings on display feature young women and shot game, both subjects testifying to the passion of pursuit. Every wall is covered with oil paintings hung close together. The outside walls are thick. No sound from the city outside penetrates.

In a small room on the ground floor, which was previously a stable for horses and is now full of showcases of armour and muskets, I imagined I heard the sound of a horse blowing through its nostrils. Then I tried to imagine choosing and buying a horse. It must be like owning nothing else. Better than owning a painting. I also imagined stealing one. Perhaps it would have been more complicated, owning a stolen horse, than adultery? Commonplace questions to which we'll never know the answer. Meanwhile I wandered from gallery to gallery.

A chandelier in painted porcelain, the candles held aloft by an elephant's trunk, the elephant wearing green, the porcelain made and painted in the royal factory in Sevres, first bought by Madame Pompadour. Absolute monarchy meant that every creature in the world was a potential servant, and one of the most persistent services demanded was Decoration.

At the other end of the same gallery was a bedroom commode which belonged to Louis XV. The inlay is in rosewood, the rococo decorations in polished bronze.

Most of the visitors, like me, were foreigners, more elderly than young, and all of them slightly on tiptoe, hoping to find something indiscreet. Such museums turn everyone into inquisitive gossips with long noses. If we dared, and could, we'd look into every drawer.

In the Dutch part of the collection, we passed drunken peasants, a woman reading a letter, a birthday party, a brothel scene, a Rembrandt, and a canvas by one of his pupils. The latter intrigued me immediately. I moved on and then quickly came back to look at it several times.

This pupil of Rembrandt was called Willem Drost. He was probably born in Leiden. In the Louvre in Paris there is a Bathsheba painted by him which echoes Rembrandt's painting of the same subject painted in the same year. Drost must have been exactly contemporary with Spinoza. We don't know where or when he died.

She is not looking at the spectator. She is looking hard at a man she desired, imagining him as her lover. This man could only have been Drost. The only thing we know for certain about Drost is that he was desired precisely by this woman.

I was reminded of something of which one is not usually reminded in museums. To be so desired – if the desire is also

reciprocal – renders the one who is desired fearless. No suit of armour from the galleries downstairs ever offered, when worn, a comparable sense of protection. To be desired is perhaps the closest anybody can reach in this life to feeling immortal.

It was then that I heard a voice. Not a voice from Amsterdam, a voice from the great staircase in the house. It was high-pitched yet melodious, precise yet rippling, as if about to dissolve into laughter. Laughter shone on it like light through a window onto satin. Most surprising of all, it was resolutely a voice speaking to a crowd of people; when it paused there was silence. I couldn't distinguish the words, so my curiosity forced me, without a moment's hesitation, to return to the staircase. Twenty or more people were slowly coming up it. Yet I couldn't make out who had been speaking. All of them were waiting for her to begin again.

'At the top of the staircase on the left you will see a three-tiered embroidery table, a woman's table, where she left her scissors and her needlework and her work could still be seen, which was better don't you think than hiding it away in a drawer? Locked drawers were for letters. This piece belonged to the Empress Josephine. The little oval blue plaques, which wink at you, are by Wedgwood.'

I saw her for the first time. She was coming up the staircase alone. Everything she wore was black. Flat black shoes, black stockings, black skirt, black cardigan, a black band in her hair. She was the size of a large marionette, about four feet tall. Her pale hands hovered or flew through the air as she talked. She was elderly and I had the impression that her thinness was to do with slipping through time. Yet there was nothing skeletal about her. If she was like one of the departed, she was like a nymph. Around her neck she wore a black ribbon with a card attached to it. On the card was printed

the famous name of The Collection and, in smaller letters, her own name. Her first name was Amanda. She was so small that the card looked absurdly large, like a label pinned to a dress in a shop window, announcing a last-minute bargain.

'In the showcase over there you can see a snuff box made of carnelian and gold. In those days young women as well as men took snuff. It cleared the head and sharpened the senses.' She raised her chin, threw her head back and sniffed.

'This particular snuff box has a secret drawer in which the owner kept a tiny gouache portrait, no larger than a postage stamp, of his mistress. Look at her smile. I would say it was she who gave him the snuff box. Carnelian is a red variety of agate, mined in Sicily. The colour perhaps reminded her in some way of him. Most women, you see, see men as either red or blue.' She shrugged her frail shoulders. 'The red ones are easier.'

When she stopped talking, she did not look at the public but turned her back and walked on. Despite her smallness, she walked much faster than her followers. She was wearing a ring on her left thumb. I suspect that her black hair was a wig for I'm sure she prefers wigs to rinses.

Our walk through the galleries began to resemble a walk through a wood. This was a question of how she placed us, herself and what she was talking about. She consistently prevented us from crowding around whatever she was explaining. She pointed out an item as if it were a deer to be glimpsed as it crossed our path between two distant trees. And wherever she directed our attention, she always kept herself elusively to the side, as if she had just stepped out from behind another tree. We came upon a statue, its marble turning a little green because of the shade and dampness.

'The statue depicts Friendship consoling Love,' she murmured, 'for Madame de Pompadour's relation with Louis XV is now platonic, which hasn't stopped her wearing, has it?, the most gorgeous dress.'

Downstairs, one gilded timepiece after another chimed four.

'Now we go', she said, holding her head high, 'to another part of the wood. Here all is fresh, and everyone is freshly dressed – including the young lady on the swing. No statues of Friendship, all the statues here are cupids. The swing was put up in the spring. One of her slippers, you notice?, has already been kicked off! Intentionally? Unintentionally? Who can tell? As soon as a young lady, freshly dressed, sits herself there on the seat of the swing, such questions are hard to answer, no feet on the ground. The husband is pushing her from behind. Swing high, swing low. The lover is hidden in the bushes in front of her where she told him to be. Her dress – it's less elaborate, more casual, than Madame de Pompadour's and frankly I prefer it – is of satin with lace flounces. Do you know what they called the red of her dress, they called it peach, though personally I never saw a peach of that colour, any more than I ever saw a peach blushing. The stockings are white cotton, a little roughish compared to the skin of the knees they cover. The garters, pink ones to match the slippers, are too small to go higher up the leg without pinching. Notice her hidden lover. The foot which lost the slipper is holding up her skirt and petticoats high – their lace and satin rustle softly in the slipstream – and nobody, I promise you, nobody in those days wore underwear! His eyes are popping out of his head. As she intended him to do, he can see all.'

Abruptly the words stopped, and she made a rustling noise with

her tongue behind clenched teeth, as though she were pronouncing only the consonants of the words lace and satin without the vowels. Her eyes were closed. When she opened them, she said: 'Lace is a kind of white writing which you can only read when there's skin behind it.'

Then she stepped sideways out of sight. The guided tour was over.

Before anybody could ask a question or thank her, she disappeared into an office behind the book counter. When she came out, half an hour later, she had taken off the ribbon around her neck with its card and put on a black overcoat. If she had stood beside me, she would have come up to my elbows, no more.

She walked briskly down the front steps of the house into the square where the poplars are. She was carrying an old flimsy Marks and Spencer's plastic bag which looked as if it might tear.

This endeavour, when it has reference to the mind alone, is called will (*voluntas*); but when it refers simultaneously to the mind and body it is called appetite (*appetitus*), which therefore is nothing else than the essence of man, from the nature of which all things which help in his preservation necessarily follow; and therefore man is determined for acting in this way. Now between appetite and desire (*cupiditas*) there is no difference but this, that desire usually has reference to men in so far as they are conscious of their appetite; and therefore it may be defined as appetite with consciousness thereof. It may be gathered from this, then, that we endeavour, will, seek, or desire nothing because we deem it good; but on the contrary, we deem a thing good because we endeavour, will, seek, or desire it.

(*Ethics*, Part III, Proposition IX)

30

What was in the Marks and Spencer's bag? I imagine a cauliflower, a pair of resoled shoes and seven wrapped presents. The presents are all for the same person and each one is numbered and tied up with the same golden twine. In the first a sea shell. A small conch about the size of a child's fist, perhaps the size of her fist. The shell is the colour of silverish felt, veering towards peach. The swirls of its brittle encrustations resemble the lace flounces on the dress of the woman on the swing, and its polished interior is as pale as skin habitually sheltered from the sun.

The second present: a bar of soap, bought at a Boots Chemist shop and labelled Arcadia. It smells of a back you can touch but can't see because you're facing the front.

The third packet contains a candle. The price tag says 8.5 EURO. In the fourth another candle. Not made of wax this time but in a glass tumbler which looks as if it is full of sea water with sand and very small shells at the bottom. The wick appears to be floating on the surface. A printed label stuck onto the glass says: Never leave a burning candle unattended.

The fifth present: a paper bag of a brand of sweets called wine gums. This brand has existed for a century. Probably they are the cheapest sweets in the world. Despite their very varied and acid colours, they all taste of pear drops.

The sixth present is an audio cassette of Augustinian nuns singing 'O Filii et Filiae', a thirteenth-century plainsong written by Jean Tisserand.

The seventh is a box of graphite sticks and pencils. Soft. Medium. Hard. Traces made by the soft graphite are jet black like thick hair, and traces made by the hard are like hair turning grey. Graphite, as skins do, has its own oils. It is a very different substance from the burnt ash of charcoal. Its sheen when applied

on paper is like the sheen on lips. With one of the graphite pencils she has written on a piece of paper which she has put in the box: 'On the last hour of the last day, one must remember this.'

Then I went back to look at the woman who was in love with the Dutch painter.

The idea which constitutes the formal being of the human mind is the idea of the body, which is composed of many individuals, each composed of many parts. But the idea of each individual composing the body necessarily exists in God. Therefore the idea of the human body is composed of the many ideas of the component parts.

(*Ethics*, Part II, Proposition XV, Proof)

Around her is a block. The block is invisible because it's totally transparent. Nor does the block restrict her movements. Is the block what separates Being from Becoming? I don't know, for this is happening where there are no words.

Normally, we face words frontally and so can read them, speak them or think them. This was happening somewhere to the side of language. Any frontal view of language was impossible there. From the side I could see how language was paper thin, and all its words were foreshortened to become a single vertical stroke – I – like a single post in a vast landscape.

The task was to dismantle the block – to take it apart and lift it off piece by piece. She allowed this to happen – No. Active and Passive have merged together. Let us say: She happened this to herself with the utmost ease. I was with her in what she (we) were doing.

We began with her head and worked downwards towards the feet. When freed of the block, the part of her body disclosed did not change in appearance. Yet it changed. It disarmed all comment. It precluded any response except that of acceptance. Or, to put it another way: faster than any possible response, the part of her body which was disclosed, claimed its own acceptance.

Although everything was done with ease, the task was tiring, at least for me. Between the removal of each portion of the block, I returned to my own body in my own bed, glad to take a rest for

a moment, until the next removal, or the next part of the dream. Was the act of dreaming synonymous with the act of dismantling the block?

I knew all the answers then. Where there are no words, knowledge comes through physical acts and through the space through which those acts are made; by permitting each act the space conferred meaning upon it and no further meaning was necessary.

Each time I felt tired I embraced her.

I don't know how many pieces the block was divided into. The task took all night.

One thing I do remember: each new part of her body disclosed by the removal of another piece of the block was equal to the preceding one. Not necessarily equal in size but in significance.

Writing now I suspect the sequence these words suggest is too simple: first head, then shoulders, then belly, then feet. We did not proceed like this.

The word *dismantle* which I have used, aware of its apparent inappropriateness, may help us here. A block or a cast enclosing another form is not usually dismantled but rather 'broken away' or 'split open'. This block, however, had not been made in one go, and so it could not be opened in one go. It had to be taken to pieces, and the pieces did not always correspond in size, in area, to the newly disclosed part of her body. Perhaps each piece of the block was unwound like a cloth from her whole body? All I know is that the process proceeded by stages and that each stage meant there was less block left. Eventually there was none.

She was there whole, looking exactly as she had at the beginning, capable of the same actions and no more, having the same

name, the same habits, the same history. Yet, freed from the block, the relations between her and everything which was not her had changed. An absolute yet invisible change. She was now the centre of what surrounded her. All that was not her made space for her.

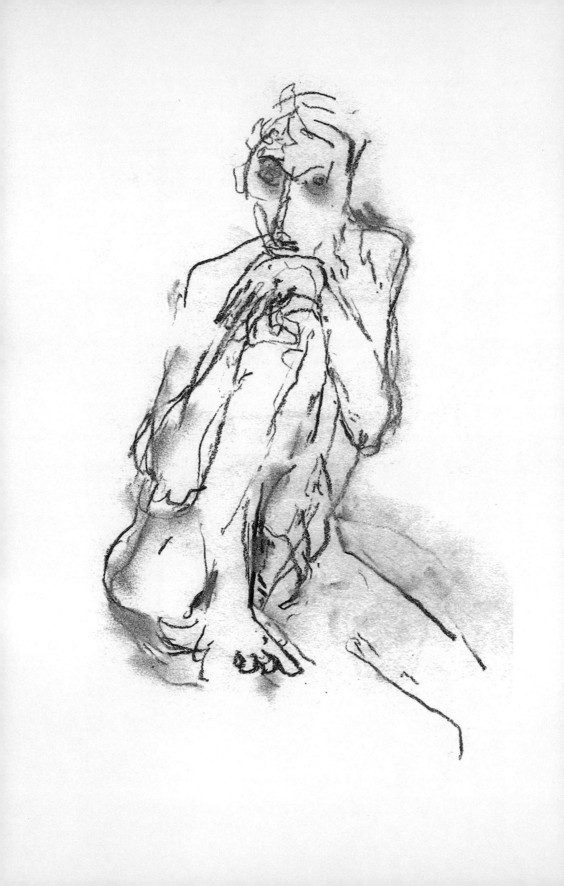

Duomo Castelfranco
16/9/02 Veneto

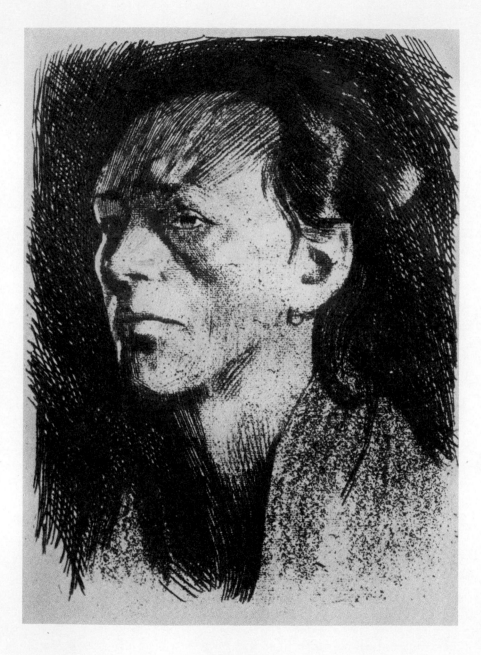

Etching by Käthe Kollwitz.

The centre of the city of Dresden was still razed to the ground when I first met Erhard Frommhold there in the early 1950s. The Allied bombing of the city on February 13, 1945, had killed in a single night 100,000 civilians; most of them burnt to death in temperatures that reached 1800° Fahrenheit. In the 1950s Frommhold was working as an editor in the VEB Verlag der Kunst.

He was my first publisher. He published a book about the Italian painter Renato Guttuso, several years before any book of mine was published in Britain. Thanks to him I discovered that, despite my doubts, I was capable of finishing a book.

Erhard was lithe and had the physical presence of an athlete or football player. Perhaps more accurately the latter, for he came from a working-class family. His energy was striking, concentrated and reticent – somewhat like the pulse at the pit of his neck.

Both his lean energy and the devastation of the city testified, at that time, to the force of history. It was history then, not brand-names, that began with a capital letter. What History signified or promised, however, was open to various interpretations. Was it better or not to let some of the sleeping dogs lie?

Erhard was two years younger than I, but I thought of him in Dresden as being several years my senior. He was more experienced, he had lived more History. He was a kind of elected elder brother. Today, when the principles of Fraternity and Equality

have been declared obsolete by every Bad Government in the world, this may sound sentimental, but it wasn't.

We were not intimate as natural brothers sometimes are. What was fraternal between us was a certain trust: an existential trust which ultimately derived from a marxist reading of history. Reading or perspective? I would say perspective, for what was essential was another sense of time, which could accommodate both the long term (centuries) and the urgent (half past two tomorrow afternoon).

We seldom talked in detail about politics – in part because we didn't have a fluent common language, but also because both of us were covertly nonconformist and opposed to simplifications. Both of us listened hard to Bertolt Brecht, who was our elected uncle.

One of Brecht's *Herr K* stories is about Socrates. Socrates is listening to some Sophist philosophers endlessly pontificating, and so finally he steps forward and states: All I know is that I know nothing! This sentence is greeted with deafening applause. And Herr K wonders whether Socrates had something to add, or whether the applause had rendered what followed inaudible for the next two thousand years!

When we heard this, we smiled and glanced at one another. And somewhere behind our agreement was the tacit recognition that any original political initiative has to start off as being clandestine, not through a love of secrecy, but because of the innate paranoia of the politically powerful.

Everyone in the DDR was aware of history, its bequests, its indifference, its contradictions. Some resented it, some tried to use it to their own advantage, most concentrated on surviving beside it and a few – a very few – tried to live with dignity whilst facing it night and day. And Erhard was among those few. This is

why he was an example for me, a hero, who had a deep effect on what I wanted to try to become.

His example wasn't an intellectual but an ethical one. It was given to me by my observing and trying to respond to his daily behaviour, the precise way he encountered events and people.

Can I define it? I never formulated it for myself; it was an almost wordless example, like the quality of a particular silence.

He gave me a touchstone for distinguishing between the false and the genuine, between – in Spinoza's terms – the inadequate and the adequate.

Touchstones, however, indicate by way of a mineral reaction, not through a discursive debate. The original touchstone was a flint reacting to silver and gold.

Writing, this, I think of the etching by Käthe Kollwitz entitled *Working-Class Woman (with earring) 1910.*

Erhard and I both admired Kollwitz. Just as History was indifferent, she was caring. Yet her horizon was no narrower. Hence the pain she shared.

Erhard looked unflinchingly at History. He measured the catastrophes of the past and their scale, and accordingly he chose proposals for a future of greater justice and more compassion, whilst never forgetting that the pursuit of those proposals was likely to involve threats, accusations and ceaseless struggle, for History, even when recognised, is eternally recalcitrant.

In the '70s, Erhard was sacked from the Verlag der Kunst, of which he was by then director, and was accused, on account of several of the books he had edited, of formalism, bourgeois decadence and factionalism. Fortunately he was not jailed. He was simply condemned to performing socially useful work: as a gardener's assistant in a public park.

Look again at the etching by Kollwitz. The earring is a small but proud declaration of hope, yet it is totally outshone by the light of the face, which is inseparable from its nobility. Meanwhile the face has been drawn with black lines from the surrounding blackness. And this perhaps is why she chose to wear earrings!

Erhard's example offered a small, undemonstrative, persistent hope. It embodied endurance. An endurance that was not passive but active, an endurance that was the result of the taking on of History, an endurance that guaranteed a continuity despite History's recalcitrance.

A sense of belonging to what-has-been and to the yet-to-come is what distinguishes man from other animals. Yet to face History is to face the tragic. Which is why many prefer to look away. To decide to engage oneself in History requires, even when the decision is a desperate one, hope. An earring of hope.

All actions which follow from the emotions which are related to the mind, in so far as it understands, I refer to fortitude, which I distinguish into courage and generosity. For I understand by courage the desire by which each endeavours to preserve what is his own according to the dictate of reason alone. But by generosity I understand the desire by which each endeavours according to the dictate of reason alone to help and join to himself in friendship all other men. And so I refer those actions which aim at the advantage of the agent alone to courage, and those which aim at the advantage of others to generosity. Therefore temperance, sobriety, and presence of mind in danger, etc., are species of courage; but modesty, clemency, etc., are species of generosity. And thus I think I have explained and shown through their primary causes the principal emotions and waverings of the mind which arise from the composition of the three primary emotions, namely, pleasure, pain and desire. And it is apparent from these propositions that we are driven about by external causes in many manners, and that we, like waves of the sea driven by contrary winds, waver, unaware of the issue and of our fate.

(*Ethics*, Part III, Proposition LIX, Note)

magnolia

By body (*corpus*) I understand a mode which expresses in a certain and determinate manner the essence of God, in so far as he is considered as an extended thing.

(*Ethics*, Part II, Definition I)

magnolias

I was in London on Good Friday, 2008. And I decided, early in the morning, to go to the National Gallery and look at the Crucifixion by Antonello da Messina. It's the most solitary painting of the scene that I know. The least allegorical.

In Antonello's work – and there are less than forty paintings which are indisputably his – there's a special Sicilian sense of *thereness* which is without measure, which refuses moderation or self-protection. You can hear the same thing in these words spoken by a fisherman from the coast near Palermo, and recorded by Danilo Dolci a few decades ago.

'There's times I see the stars at night, especially when we're out for eels, and I get thinking in my brain, "The world, is it really real?" Me, I can't believe that. If I get calm, I can believe in Jesus. Bad-mouth Jesus Christ and I'll kill you. But there's times I won't believe, not even in God. "If God really exists, why doesn't He give me a break and a job?" '

In a Pietà painted by Antonello – it's now in the Prado – the dead Christ is held by one helpless angel who rests his head against Christ's head. The most piteous angel in painting.

Sicily, island which admits passion and refuses illusions.

I took the bus to Trafalgar Square. I don't know how many hundred times I've climbed the steps from the square that lead up to the Gallery and to a view, before you enter, of the fountains seen from above. The Square, unlike many notorious city

49

assembly points – such as the Bastille in Paris – is, despite its name, oddly indifferent to history. Neither memories nor hopes leave a trace there.

In 1942 I climbed the steps to go to piano recitals given in the Gallery by Myra Hess. Most of the paintings had been evacuated because of the air-raids. She played Bach. The concerts were at midday. Listening, we were as silent as the few paintings on the walls. The piano notes and chords seemed to us like a bouquet of flowers held together by a wire of death. We took in the vivid bouquet and ignored the wire.

It was the same year, 1942, that Londoners first heard on the radio – in the summer, I think – Shostakovich's 7th Symphony, dedicated to besieged Leningrad. He had begun composing it in the city during the siege in 1941. For some of us the symphony was a prophecy. Hearing it, we told ourselves that the resistance of Leningrad, now being followed by that of Stalingrad, would finally lead to the Wehrmacht's defeat by the Red Army. And this is what happened.

Strange how in wartime music is one of the very few things which seem indestructible.

I find the Antonello Crucifixion easily, hung at eye-level, left of the entry to the room. What is so striking about the heads and bodies he painted is not simply their solidity, but the way the surrounding painted space exerts a pressure on them and the way they then resist this pressure. It is this resistance which makes them so undeniably and physically present. After looking for a long while, I decide to try to draw only the figure of Christ.

A little to the right of the painting, near the entry, there is a chair. Every exhibition room has one and they are for the official gallery attendants, who keep an eye on the visitors, warn them if they go too close to a painting, and answer questions.

As an impecunious student I used to wonder how the attendants were recruited. Could I apply? No. They were elderly. Some women but more men. Was it a job offered to certain city employees before retirement? Did they volunteer? Anyway, they come to know some paintings like their own back gardens. I overheard conversations like this:

Can you tell us please where the works by Velázquez are?

Yes, yes. Spanish School. In Room XXXII. Straight on, turn right at the end then take the second on your left.

We're looking for his portrait of a stag.

A stag? That's to say a male deer?

Yes, only his head.

We have two portraits of Philip the Fourth – and in one of them his magnificent moustache curls upwards, like antlers do. But no stag, I'm afraid.

How odd!

Perhaps your stag is in Madrid. What you shouldn't miss here is Christ in the house of Martha. Martha's preparing a sauce for some fish, pounding garlic with a pestle and mortar.

We were in the Prado but there was no stag there. What a pity!

And don't miss our Rokeby Venus. The back of her left knee is something.

The attendants always have two or three rooms to survey and so they wander from one room to another. The chair beside the Crucifixion is for the moment empty. After taking out my sketchbook, a pen and a handkerchief, I carefully place my small shoulder bag on the chair.

I start drawing. Correcting error after error. Some trivial. Some not. The crucial question is the scale of the cross on the page. If this is not right, the surrounding space will exert no pressure, and

there'll be no resistance. I'm drawing with ink and wetting my index finger with spit. Bad beginning. I turn the page and restart.

I won't make the same mistake again. I'll make others, of course. I draw, correct, draw.

Antonello painted, in all, four Crucifixions. The scene he returned to most, however, was that of Ecce Homo, where Christ, released by Pontius Pilate, is put on display, mocked, and hears the Jewish high priests calling for his Crucifixion.

He painted six versions. All of them close-up portraits of Christ's head, solid in suffering. Both the face and painting of the face are unflinching. The same lucid Sicilian tradition of taking the measure of things – without either sentimentality or flattery.

Does the bag on the chair belong to you?

I glance sideways. An armed security guard is scowling and pointing at the chair.

Yes, it's mine.

It's not your chair!

I know. I put my bag there because nobody was sitting on it. I'll remove it straightaway.

I pick up the bag, take one step left to the painting, place the bag between my feet on the floor, and re-look at my drawing.

That bag of yours cannot stay on the floor.

You can search it – here's my wallet and here are things to draw with, nothing else.

I hold the bag open. He turns his back.

I put the bag down and start drawing again. The body on the cross for all its solidity is so thin. Thinner than one can imagine before drawing it.

I'm warning you. That bag cannot stay on the floor.

I've come to draw this painting because it's Good Friday.

It's forbidden.

I continue drawing.

If you persist, the security guard says, I'll call the Super.

I hold the drawing up so he can see it.

He's in his forties. Stocky. With small eyes. Or eyes that he makes small with his head thrust forward.

Ten minutes, I say, and I'll have finished it.

I'm calling the Super now, he says.

Listen, I reply, if we have to call, let's call somebody from the Gallery staff and with a bit of luck they'll explain that it's OK.

Gallery staff have nothing to do with us, he grunts, we're independent and our job is security.

Security my arse! But I don't say it.

He starts to pace slowly up and down like a sentry. I draw. I'm drawing the feet now.

I count to six, he says, then I call.

He's holding his cell phone to his mouth.

One!

I'm licking my finger to make grey.

Two!

I smudge the ink on the paper with my finger to mark the dark hollow of one hand.

Three!

The other hand.

Four! He strides towards me.

Five! Put your bag on your shoulder.

I explain to him that, given the size of the sketch pad, if I do this, I can't draw.

Bag on your shoulder!

He picks it up and holds it in front of my face.

I close the pen, take the bag and I say Fuck out loud.

Fuck!

His eyes open and he shakes his head, smiling.

Obscene language in a public place, he announces, nothing less. The Super's coming.

Relaxed now, he circles the room slowly.

I drop the bag on the floor, take out my pen and take another look at the drawing. The ground has to be there to limit the sky. With a few touches I indicate the earth.

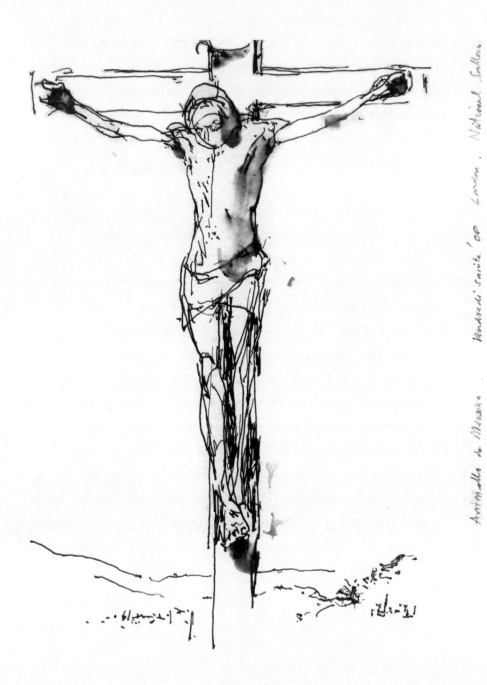

Antonello da Messina Vendredi saint '69 London. National Gallery

When the Super arrives, he stands, arms akimbo, more or less behind me, to announce: You will leave the Gallery under escort. You have insulted one of my men who was doing his job, and you have shouted obscene words in a public institution. You will now walk in front of us to the main exit. I take it you know the way.

They escort me down the steps into the square. There they leave me, and energetically jog up the steps, mission accomplished.

Now many errors consist of this alone, that we do not apply names rightly to things. For when any one says that lines which are drawn from the centre of a circle to the circumference are unequal, he means, at least at the time, something different by circle than mathematicians. Thus when men make mistakes in calculation they have different numbers in their minds than those on the paper. Wherefore if you could see their minds they do not err; they seem to err, however, because we think they have the same numbers in their minds as on the paper. If this were not so we should not believe that they made mistakes any more than I thought a man in error whom I heard the other day shouting that his yard had flown into his neighbour's chickens, for his mind seemed sufficiently clear to me on the subject.

(*Ethics*, Part II, Proposition XLVII)

Perhaps –

Sphinx de Garenne . –

More probably

Sphinx de Tilleul

actual
size

pink red "tail" ← this is defensive position.

– pale green .
(primrose leaf)

actual size

← suction feet .

between the 10ᵗʰ "vertebrae" the body

is jet black ~~is black~~ .. Each vertebra has its 2 feet

tail comes from last vertebra ~~head~~

head

foot → leg . 3 "forelegs"
7 "hindlegs"

The bicycle I made a drawing of this morning is over sixty years old.

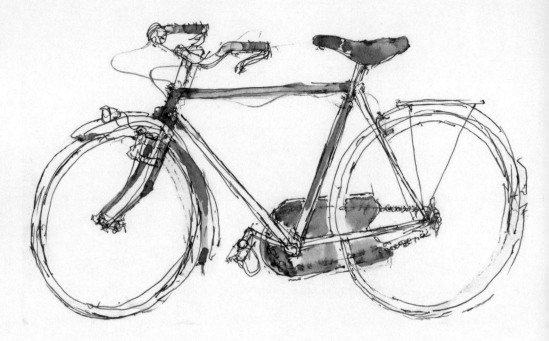

It belongs to Luca, who lives in a suburb to the southeast of Paris. He makes local visits on his bike when the weather is fine and he doesn't want to take his car out of his garage. The garage is under his home – a ramp leads down to it – and is half the width of the narrow house of which he became the second owner fifty years ago.

On the bike he goes to call on friends or to play petanque and cards or to look down from a bridge at the traffic on the motorway. He is sprightly and has a bushy moustache, the bottom of which is pure white, like his hair. He makes many jokes and their bantering humour is recognisably Italian.

It's hot, I say to him, I'm going for a swim in the municipal swimming pool, coming? He shakes his head and says: I know! A lot of water in it and very little meat!

When he smiles you mistake the white of the bottom of his moustache for the white of his teeth. He has steady eyes. You can observe him closely observing. His hands are as deft as his eyes are observant. He can fix and repair almost any everyday appliance and he does so for himself, his grown-up children and for any neighbour who has the modesty to ask him.

Each evening he notes in a calendar his brief observations about the day. He started doing this when he retired twenty-five years ago. He notes the weather when it's exceptional, the date when he plants something in his small back garden,

any repairs made, any maintenance task accomplished, the death of an old friend, gossip about neighbours in the street, and, above all, he makes notes about work which he has observed being well or carelessly done on the little houses or along the residential roads he passes by each day. When he considers the work exceptionally well done, he marks it with his initials. For work badly done he reserves a number of violent adjectives. (Carelessness for him is a reminder of the farce that life risks becoming.) Sometimes he notes what he has eaten. Occasionally he sticks in a newspaper cutting, usually a photograph of a faraway place.

During thirty years Luca worked for Air France as a Performance Controller of aircraft.

In his garden he grows tomatoes, lettuces, roquette and asters. The name aster, he points out, means 'star' in Ancient Greek.

The bicycle was given to him by his mother when he was fifteen years old. Both parents were Italian: father, a tailor, mother, a dressmaker. They came to the same Parisian suburb in the 1920s, after Mussolini's March on Rome and the Fascist takeover.

During the Second World War and the German occupation of Paris, the father named his dog Hitler. Consequently, when taking it for a walk along the local, crowded shopping street, he would shout: To Heel Hitler! Down Hitler! Do you want a thrashing?

When he first arrived from Italy the father found a shed, measuring thirty square metres, near the Croix de Berny. There the whole family lived and worked in their own sweatshop, making women's dresses to measure for French housewives, whose husbands were among the first French artisans to decide to buy little houses of their own on the outskirts of the city, rather than live in apartments.

After school, from the age of nine, Luca sold evening newspapers outside the nearby metro station. He would get home an hour before bedtime. When he was older he would wander over to the diggings in the marshes, where casual labourers extracted buckets of gypsum which they sold to a nearby plaster factory. These marshes extended then to where his house stands today.

It was wet, badly paid, dirty work, he remembers.

The crystalline structure of the gypsum sometimes set me dreaming of El Dorados – you know calcium sulphate is the same stuff, more or less, as our bones are made of? You didn't know that! Here, I'll give you a memento! He goes over to a cabinet of narrow drawers in a corner of his garage, opens one and takes out a small fragment of crystal. Monoclinic prismatic, he says, and hands it to me. May it bring you luck . . .

$CaSO_4 \, 2H_2O$

When he was thirteen he started helping out as a mechanic's mate for an Italian who had a garage repair workshop. At that time there were many Italians in the area, employed on construction sites for the extension of Orly Airport. And it was an Italian camarade who, a year or so later, got Luca a trial run, working as a riveter on the assembly line of a small Forman aircraft factory next to Orly. He was taken on. He got his first month's wages.

He had told them nothing about the new job at home. He handed the money over to his mother. She said: How did you get so much? Have you told your father? You stole it! Luca shook his head. His mother nodded. He hadn't told his father out of a kind of filial respect for the father's pride. The father now had another dog. Both Hitlers were dead. This one he called Money. In the sweatshop after supper the father would hold up a piece of panettone before the dog and say: Sit up and beg, Money! That's it! Into your basket, Money!

The following week, without a word to anyone, his mother went and bought him a bicycle. The one I drew this morning.

On his new bike Luca would cycle around the perimeter of the airport, which was then the largest in France. He often stopped, chatted, asked questions.

When Air France was created, he applied for work as an apprentice mechanic and, given his experience at the Forman factory, was accepted. He attended Air France's own Technical School which was on the airport. He was methodical and gifted. And he graduated from the School as a Grade 1 Control Mechanic.

Older men enjoyed working with him, for he was quick, jokey and at the same time calm. Precision was for him a source of pleasure, not a constriction. They gave him the nickname of Rabbit – which meant in their vocabulary an object revealed by radar.

He met a Parisian woman named Odille. He called her My Rosalie. She liked to read, particularly long novels. And this was fortunate, for his work often took him away from Paris for days on end, when he was sent with other *meccanos* to work on a plane that had for some reason been grounded at a foreign airport and needed revision. She had hair that fell over her face like sunlight, he says when showing me one of their old wedding photos. Their first son was born in '59. Their second eight years later.

In the early '70s Luca was promoted to rank of Engineer Controller. Controllers worked in teams of five. Air France, with one hundred jet aircraft, including Caravelles, Boeing 747s, Airbuses, Concordes, had become the largest passenger airline in the world, and the second largest freight airline.

Their job was to calibrate and check the controls of an aircraft after it had been delivered, repaired, modified, overhauled or renovated. They tested and tuned every circuit: reactors, generator, cooling system, ailerons, flaps, rudder, fuselage, oxygen, pressurisation, radar, radio. They did this when the plane was on the ground, and then, with the cooperation of the flying crew, when it was airborne. Each controller had his own sector, although in principle the five were interchangeable. Luca's was the cockpit instrument panel: altimetre, wind-gauge, turn and bank indicator, variometre, gyrocompass, VSI, pilot head, etc., etc.

The work was demanding and meticulous. On occasions it involved travelling to airports on the other side of the world. Working hours were irregular. No error would be forgotten. Yet it was well paid and relatively uncompetitive – controllers, flying crew, chief engineers became used to meeting up again

and again, collaborating and depending upon one another – like musicians performing at the same gig, each time playing something new.

The Rabbit was proud of his skills. They were minute, within a hair's breadth, and they were far-reaching. When a control was finished, each of the team of five initialled a CDN (Certificate of Air Worthiness). After which it was assumed that the aircraft in question could be counted on for 2,500 more flying hours before its next overhaul.

The Rabbit's initials were like this: *dMc*

He bought the house he now lives in. He helped out his parents. He paid regularly into his savings account. And when he saw retirement approaching at the age of sixty he felt rewarded.

Rosalie and he would travel to some of the cities he had discovered when on mission. He'd spend time with his grandchildren. He'd see old comrades. And he'd make prototypes for one or two inventions he had in his head.

A few years after he retired, Rosalie began to go out of her mind. She would leave the house, follow some story she was inventing and then be unable to find her way home. Eventually she was diagnosed as suffering from Alzheimer's.

Luca took her in charge and looked after her, but Rosalie continued to lose her faculties one by one, and finally had to be hospitalised. Luca visited her each day and fed her, with a spoon, her evening meal. Often she failed to recognise him. Time went on, and apparently she never recognised him. But if I didn't go, he reasoned, perhaps she would recognise my absence!

After a few months the hospital announced it could no longer keep her and that Luca must find a private nursing home. He began searching. He wanted her to have a room of her own, and

64

for it to be not too far from the Croix de Berny. There was only one such residence. It had twenty beds, and with food and nursing facilities cost 3,500 euros a month.

He drove Rosalie there and she smiled, so he took the room she smiled in.

The same night he carefully consulted his bank statement and opened his calendar.

She will be fine there, he wrote, for three years, which is to say 1,095 days. After that, we'll have nothing left. Then he added his initials: ΔΜ

How can destinies be named? They often have the regularity of geometric figures, but there are no nouns for them. Can a drawing replace a noun? I thought so this morning. Now I'm not so sure. I gave Luca the drawing, and the next day he framed it.

The more an image is joined with many other things, the more often it flourishes.

The more an image is joined with many other things, the more causes there are by which it can be excited.

(*Ethics*, Part V, Proposition XIII, Proof)

"Only free men are thoroughly grateful me to another." Ethics. Pt. IV. Prop. LXXI

I see the face of Anton Chekhov. 'The role of the writer', he said, 'is to describe a situation so truthfully . . . that the reader can no longer evade it.'

How to apply this advice today?

I have no answer, only a hunch which stutters like any story before it's told.

I want to compare two experiences of being with a lot of people dancing. Both events took place a week ago in an alpine valley, within a few kilometres of each other.

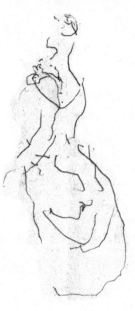

The first was at the wedding party of an Algerian bride and a Moroccan bridegroom. We, friends of the bride's mother and invited by her, were the only Europeans present. There were 150 guests. All of them, and spectacularly for the women, dressed up for the occasion, since a marriage permits – or demands – extravagance.

Traditionally on their wedding day, the couple, however modest, sits on shining thrones. In the ritual of such weddings women dominate. Women of all ages from young teenagers to grandmothers.

Put it another way, it is at weddings that these Maghrebian women are encouraged to extend their domain and demonstrate their power, whereas normally any show or any practice of authority in a public situation is a male prerogative.

At weddings the queens (who are menial workers in the French economy) take over the palace.

The dinner – without alcohol – is copious and continuous. All the chairs at the tables have been covered by white drapes with flounces so that they look like bridesmaids. The bride and bridegroom sit on their thrones on a podium. (During the evening the bride will change dresses four times.) There's music. Sometimes loud, stopping conversations, sometimes soft and enticing. Dance music. Mostly raqs baladi.

There were continually dancers on the floor. The women danced with men but more often alone. When the bride and bridegroom stepped off the podium to dance, the number of dancers increased so that the moment might be more widely shared. Teenagers, mothers, grandmothers, whose clothes and get-up had so little in common, all danced in the same manner. Shimmying.

The other event was in the playground of a closed-down village school and the occasion was the fiftieth birthday party of the man who is now living there. He's a local Lycée teacher and he has a Moto Guzzi California 3 bike (1,000cc). A long summer evening. Trestle tables loaded with dishes brought by guests. Beer. Wine. A Pissaladiere, made by the teacher himself, with anchovies and sweet onions and black olives, round as a full moon, cut with a bread knife. He learnt the recipe as a kid from his mother in Marseilles. She's here too tonight in the playground. Later a paella, which the teacher's son ordered from a Spanish friend, is brought in. Most of the guests are in their thirties, some are ex-pupils from the schools the teacher has taught in.

The music is from the '80s. The Blues Brothers. U2. Les Rita Mitsouko.

The mood of the guests is friendly, uncompetitive and undisappointed, because they have no illusions about who for the moment is ruling the world, yet the world is large.

As soon as the music is plugged in and the loudspeaker adjusted, a few start dancing – mostly not in couples. 'Look at a mirror/in my tea/watching it in my cup/change a little my make-up/in my tea . . .'

Others watch or go on talking. There are about thirty of us in the asphalt playground – the same as the number of kids the village school was designed for, when it was built in the 1920s.

The dancing is happy, repetitive, easy-going, energetic, hallucinated. I could apply exactly the same adjectives to the dancing at the wedding, yet the two manners of dancing are deeply different. What is this difference?

I might say: one is introverted, the other extroverted. Not psychologically but corporally, in terms of focus and attention.

For the women at the wedding, dance offered the chance of drawing attention to what they were carrying hidden within themselves, and the men danced in face of, and around, that which was hidden. *Intro* = inwards, *vertere* = to turn.

For the guests at the birthday party the beat and surge of the music encouraged them to disclose, and expose, their own vitalities to the company. Had one of them been dancing alone, the disclosure would have been to the playground or to the night. They were each of them adventuring out and signalling, along the way, their approach. *Extro* = outwards, *vertere* = to turn.

The difference between the two ways of dancing becomes clearer if we simplify them to a ritualistic form. The 'introverted' dance would become the raqs sharqi (the belly dance). The 'extroverted' dance would become the striptease.

Both are sexy and enticing, but their strategies and ontology are opposed. It's the difference between hiding and displaying. Which, in this case, has nothing to do with modesty or brazenness. Both are immodest. It's a question of the priority given to the hidden or the displayed, to the invisible or the visible, to the contained or the free.

For the raqs sharqi the invisible is, by its nature, hidden, because it is something that exists *inside* the body. Dancers say the best condition for dancing the raqs sharqi is when the dancer has recently learnt that she is pregnant. The hidden enfolds the mysterious, which is the future and which represents continuity.

The striptease, by contrast, celebrates the revealed. For sure, it titillates. It plays with feints. It uses suspense. It can be used as a commercial or pathetic manipulative device. But finally it offers, for a moment, the undisguised. It offers an individual naked truth.

Compared to traditional ballroom dancing, which is orchestrated and directed by strict conventions, both these ways of dancing are means of self-expression, allowing for innovation and collaboration. In this sense they are both informal.

Now for the question: can these two manners of dancing help us to distinguish more clearly between two different ways of telling stories, two different procedures of narration?

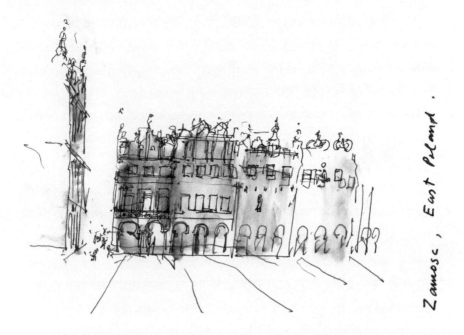

Zamosc, East Poland.

A story's outcome. My hunch is that this could be a useful term for facing the challenge Anton Chekhov left us. Outcome: like coming out of a house or residence, coming out into the street.

Traditionally the term refers to how a story ends, to what finally happens to the protagonists. A tragic, happy or transcendental ending.

Yet it can also refer to how the listener or reader or spectator leaves the story to continue their ongoing lives. Where does the story deposit those who have followed it, and in what frame of mind are they?

The answer to this question may depend upon what the story has uncovered and revealed, or upon its moral imperative, if it has included one. But, according to my hunch, there's another more interesting answer.

In following a story, we follow a storyteller, or, more precisely, we follow the trajectory of a storyteller's attention, what it notices and what it ignores, what it lingers on, what it repeats, what it considers irrelevant, what it hurries towards, what it circles, what it brings together. It's like following a dance, not with our feet and bodies, but with our observation and our expectations and our memories of lived life.

Throughout the story we become accustomed to the storyteller's particular procedure of bestowing attention, and of then making a certain sense of what was at first glance chaotic. We begin to acquire his storytelling habits.

And if the story has impressed us, something of these habits, something of its way of giving attention, will remain with us and become our own. We will then apply it to the chaos of ongoing life, in which multitudes of stories are hidden.

This 'inheritance' is what I mean by a story's *outcome*. Every storyteller has her or his own procedure. No two are alike.

Yet, if we imagine the stories being told across the world tonight and consider their *outcome*, I believe we'll find two main categories: those whose narratives are emphasising something essential that is hidden, and those which emphasise the revealed.

To comment on the two categories of storytelling we need to look at other world events.

A hand-knitted baby's jacket laid out on the kitchen table when we came back to the house after a visit elsewhere. The front door was not locked. Clearly it was a present for our grandson, who is three months old. There was no indication about who had knitted it and left it as a present on the kitchen table.

For me it epitomised warmth. Warmth of two kinds. The warmth which such thick wool, when worn, proffers the baby. (Last night it was -15°C outside.) And the sentimental warmth which inspires the neighbourly tradition of knitting for the newly born.

Next day an e-mail announced that the knitted jacket was a present from M-T., who lives 300 metres away and is herself a grandmother.

There's a Greek statue from 500 BC which shows a *kore* (a young woman) with plaited hair, a bracelet and a crown, and she is wearing a knitted woollen sweater (carved in marble!) whose cable stitch is similar to that used by M-T.

I first met her thirty-five years ago when she was a young woman. It was in one of her father's fields where several of us were haymaking. He had a large moustache and intense eyes.

The hay cart was drawn by a mare – there was no tractor and no mechanisation of any kind. Six or seven of us loaded the cart with wooden hay forks and used them again to arrange the hay in the stifling barn. After four carts we'd sit in the kitchen to drink coffee and cider before unloading the last cart in the barn.

Today M-T. is a computer fan – hence the explanatory e-mail. She adores downloading and dispatching. I walked across the village to thank her for the knitted baby jacket. It was dusk and I could see a light on through her kitchen window.

Mary Magdalene's hands from Crucifixion by Perugino.

The human capacity for cruelty is limitless. Maybe *capacity* is not the right word, for it suggests an active energy, and, in this case, such energy is not limitless. Human indifference to cruelty is limitless. So also are the struggles against such indifference.

All tyrannies involve institutionalised cruelties. To compare one tyranny with another in this respect is pointless, because, after a certain point, all pains are incomparable.

Tyrannies are not only cruel in themselves, they also exemplify cruelty and thus encourage a capacity for it, and an indifference in the face of it, amongst the tyrannised.

In his searing, unforgettable book, written in the late 1950s, Vasily Grossman tells the story of a man who after thirty years in the Gulag is 'rehabilitated.'

He visited the Hermitage – to find that it left him cold and bored. How could all those paintings have remained as beautiful as ever while he was being transformed into an old man, an old man from the camps? Why had they not changed? Why had the faces of the marvellous Madonnas not aged? How come their eyes had not been blinded by tears? Maybe their immutability – their eternity – was not a strength but a weakness? Perhaps this was how art betrays the human beings that have engendered it?

(V. Grossman, *Everything Flows*, NYRB, p. 52)

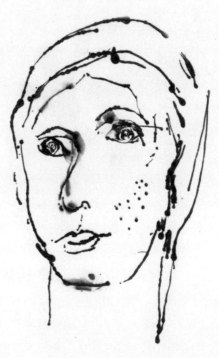

French wooden statue of Madonna. (15ᵗ. cent.)

What is distinct about today's global tyranny is that it's face-less. There's no Führer, no Stalin, no Cortés. Its workings vary according to each continent and its modes are modified by local history, but its overall pattern is the same, a circular pattern.

The division between the poor and the relatively rich becomes an abyss. Traditional restraints and recommendations are shattered. Consumerism consumes all questioning. The past becomes obsolete. Consequently people lose their selfhood, their sense of identity, and they then locate and find an enemy in order to define themselves. The enemy – whatever their ethnic or religious nomination – is always found amongst the poor. This is where the circular pattern is vicious.

The system economically produces, alongside wealth, more and more poverty, more and more homeless families, whilst simultane-ously it politically promotes ideologies which articulate and justify the exclusion and eventual elimination of the hordes of new poor.

It is this new politico-economic circle which today encour-ages the constant human capacity for cruelties that obliterate the human imagination.

'Last night a friend from Vadodara called. Weeping. It took her fifteen minutes to tell me what the matter was. It wasn't very complicated. Only that a friend of hers, Sayeeda, had been caught by a mob. Only that her stomach had been ripped open and stuffed with burning rags. Only that after she died, someone carved "OM" on her forehead.' (OM is a sacred signature of the Hindus.)

There are Arundhati Roy's words. She is describing the massa-cre of a thousand Muslims by Hindu fanatics in the Indian state of Gujarat in the spring of 2002.

'We write', she once confessed, 'on yawning gaps in the walls that once had windows. And people who still have windows sometimes cannot understand.'

Field near Nowy Targ, Poland.

Go into a field, observe, investigate, report, rewrite, write a final version, it's published, it's widely read – though one never really knows what is wide and what is thin – become a controversial writer, frequently threatened, also supported, writing about the fate of millions of people, women, men, children, get accused of contempt, go on writing, go on unravelling other projects of the powerful which are leading to more immense and avoidable tragedies, make notes, cross and re-cross the continent, bear witness to the evident desperation, continue to be published and argued with again and again, month after month, and the months add up to years. I'm thinking of you, Arundhati. Yet what one is warning and protesting against continues unchecked and remorselessly. Continues irresistibly. Continues as if in a permissive, unbroken silence. Continues as if nobody had written a single word. So one asks oneself: Do words count? And there must sometimes come back a reply something like this: Words here are like stones put into the pockets of roped prisoners before they are thrown into a river.

Let's analyze it: every profound political protest is an appeal to a justice that is absent, and is accompanied by a hope that in the future this justice will be established; this hope, however, is not the *first* reason for the protest being made. One protests because not to protest would be too humiliating, too diminishing, too deadly. One protests (by building a barricade, taking up arms, going on a hunger strike, linking arms, shouting, writing) in order to *save the present moment*, whatever the future holds.

To protest is to refuse being reduced to a zero and to an enforced silence. Therefore, at the very moment a protest is made, if it is made, there is a small victory. The moment, although passing like every moment, acquires a certain indelibility. It passes, yet it

has been printed out. A protest is not principally a sacrifice made for some alternative, more just future; it is an inconsequential redemption of the present. The problem is how to live time and again with the adjective *inconsequential*.

'The question here, really,' replies Arundhati, 'is what have we done to democracy? What have we turned it into? What happens once democracy has been used up? When it has been hollowed out and emptied of meaning? What happens when each of its institutions has metastasized into something dangerous? What happens now that democracy and the free market have fused into a single predatory organism with a thin, constricted imagination that revolves almost entirely around the idea of maximizing profit? Is it possible to reverse this process? Can something that has mutated go back to being what it used to be?'

How to live with the adjective *inconsequential*? The adjective is temporal. Perhaps a possible and adequate response is spatial? To go closer and closer to what is being redeemed from the present within the hearts of those who refuse the present's logic. A story-teller can sometimes do this.

The refusal of the protesters then becomes the feral cry, the rage, the humour, the illumination of the women, men and children in a story. Narrative is another way of making a moment indelible, for stories when heard stop the unilinear flow of time and render the adjective *inconsequential* meaningless.

Osip Mandelstam, before he was killed by the Gulag, said this precisely: 'For Dante time is the content of history felt as a single synchronic act. And inversely the purpose of history is to keep time together so that all are brothers and companions in the same quest and conquest of time.'

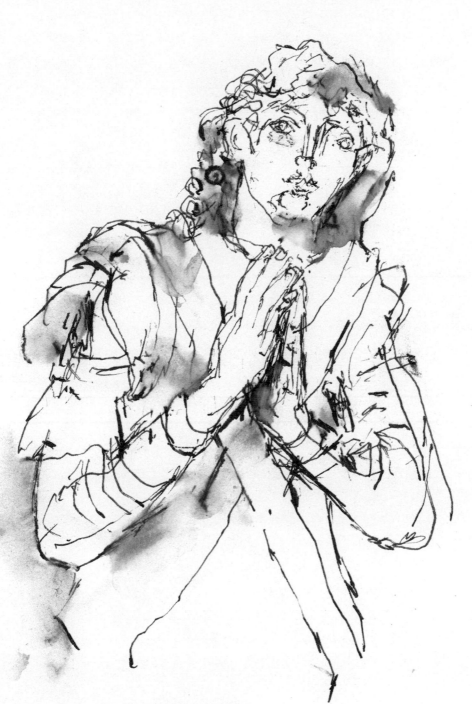

Angel by Della Robbia.

Dostoevsky's novel *The Brothers Karamazov*. I looked on the shelves over there and couldn't find it – is it perhaps in another section? Russian Literature or something?

The librarian consulted a computer. We both waited. The wait was friendly, full of the special time that wanders in municipal libraries, like a solitary walker between trees in a wood.

She lifts her head and says: We have two copies and I'm afraid they're both out. You want to reserve one?

I'll come back another day.

She nods and turns to attend to an elderly woman – younger than me – who is holding three books in one hand. People hold books in a special way – like they hold nothing else. They hold them not like inanimate things but like ones that have gone to sleep. Children often carry toys in the same manner.

The public library is in a Paris suburb which has a population of around 60,000. About 4,000 people are members of the library and have tickets for borrowing books (four at a time). Others come to read the papers and journals or consult the reference shelves. If one takes into account the number of babies and young kids in the suburb, this means that about one person in ten has a ticket and sometimes takes home books to read.

I wonder who's reading *The Brothers Karamazov* here today. Do the two of them know each other? Unlikely. Are they both

reading the book for the first time? Or has one of them read it and, like myself, wants to reread it?

Then I find myself asking an odd question: if either of those readers and myself passed one another – in the suburban market on Sunday, coming out of the metro, on a pedestrian crossing, buying bread – might we perhaps exchange glances that we'd both find slightly puzzling? Might we, without recognising it, recognise one another?

When we are impressed and moved by a story, it engenders something that becomes, or may become, an essential part of us, and this part, whether it be small or extensive, is, as it were, the story's descendant or offspring.

What I'm trying to define is more idiosyncratic and personal than a mere cultural inheritance; it is as if the bloodstream of the read story joins the bloodstream of one's life story. It contributes to our becoming what we become and will continue to become.

Without any of the complications and conflicts of family ties, these stories that shape us are our coincidental, as distinct from biological, ancestors.

Somebody in this Paris suburb, perhaps sitting tonight in a chair and reading *The Brothers Karamazov*, may already, in this sense, be a distant, distant cousin.

There are two categories of storytelling. Those that treat of the invisible and the hidden, and those that expose and offer the revealed. What I call – in my own special and physical sense of the terms – the introverted category and the extroverted one. Which of the two is likely to be more adapted to, more trenchant about what is happening in the world today? I believe the first.

Because its stories remain unfinished. Because they involve sharing. Because in their telling a body refers as much to a body of people as to an individual. Because for them mystery is not something to be solved but to be carried. Because, although they may deal with sudden violence or loss or anger, they are long-sighted. And, above all, because their protagonists are not performers but survivors.

If we return to Anton's challenge, what does this mean? It does not offer a recipe. What it offers is a certain kind of lens for observing the stories asking to be told.

Living, as distinct from literary, speech is continually interrupted, and there is never a single thread. Observe and listen to the chorus of actions undertaken together. Common actions which are as unforeseeable as conflicts.

Laughter is not a reaction but a contribution. What can happen in twenty-four hours may outlast a century.

Motives when shared are clearer than talk. Silence can be like a hand extended. (Or, of course, under different circumstances,

like a hand cut off.) The talkative poor are surrounded by silence and such silence often protects; the talkative rich are surrounded by unanswered questions.

There are two forms of continuity: the acknowledged one of institutions and the unacknowledged one of clandestinity.

Accept the unknown. There are no secondary characters. Each one is silhouetted against the sky. All have the same stature. Within a given story some simply occupy more space.

Write by hand with a knuckle bleeding. Like this blood underlines some of the words.

Every story is about an achievement, otherwise there's no story. The poor use every kind of ruse but no disguise. The rich are usually disguised until they die. One of their most common disguises is Success. There is often nothing to show for achievement except a shared look of recognition.

The heartfelt hopes, once exemplified in triumphant Hollywood stories, have now become obsolete and belong to another epoch. Hope today is a contraband passed from hand to hand and from story to story.

Sister Lucia o.s.b

Finally, by perfection in general I shall understand, as I said, reality, that is, the essence of anything, in so far as it exists and operates in a certain manner, without any consideration of duration. For no particular thing can be said to be more perfect because it has remained in existence longer: the duration of things cannot be determined by their essence, since the essence of things does not involve a certain and determinate time of existing; but everything, whether it be more or less perfect, will always be able to persist in existing with the same force with which it began to exist, so that in this all things are equal.

(*Ethics*, Part IV, Preface)

Beech trees awaiting leaves.

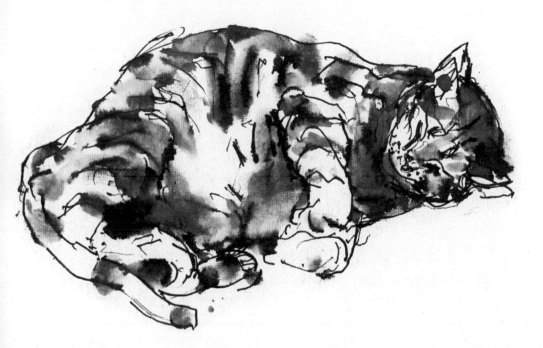

As long as the human body is affected in a way which involves the nature of any external body, so long the human mind regards the same body as present; and consequently as long as the human mind regards any external body as present, that is as long as it imagines, so long the human mind is affected in a way which involves the nature of the external body . . .

(*Ethics*, Part III, Proposition XII)

The Prado in Madrid is unique as a meeting place. The galleries are like streets, crowded with the living (the visitors) and the dead (the painted).

But the dead have not departed; the 'present' in which they were painted, the present invented by their painters, is as vivid and inhabited as the lived present of the moment. Occasionally more vivid. The inhabitants of those painted moments mingle with the evening's visitors and together, the dead and the living, they transform the galleries into a Rambla.

I go in the evening to find the portraits of the buffoons painted by Velázquez. They have a secret which it has taken me years to fathom and which maybe still escapes me. Velázquez painted these men with the same technique and the same sceptical but uncritical eye as he painted the Infantas, the Kings, courtiers, serving maids, cooks, ambassadors. Yet between him and the buffoons there was something different, something conspiratorial. And their discreet, unspoken conspiracy concerned, I believe, appearances – that's to say, in this context, what people look like. Neither they nor he were the dupes or slaves of appearances; instead they played with them – Velázquez as a master-conjuror, they as jesters.

Of the seven court jesters whom Velázquez painted close-up portraits of, three were dwarfs, one was boss-eyed, and two were rigged out in absurd costumes. Only one looked relatively normal – Pablo from Valladolid.

Their job was to distract from time to time the Royal Court and those who carried the burden of ruling. For this the buffoons of course developed and used the talents of clowns. Yet the abnormalities of their own appearances also played an important role in the amusement they offered. They were grotesque freaks who demonstrated by contrast the finesse and nobility of those watching them. Their deformities confirmed the elegance and stature of their masters. Their masters and the children of their masters were Nature's prodigies; they were Nature's comic mistakes.

The buffoons themselves were well aware of this. They were Nature's jokes and they took over the laughter. Jokes can joke back at the laughter they provoke, and then those laughing become the funny ones – all prodigious circus clowns play upon this seesaw.

The Spanish buffoon's private joke was that what anyone looks like is a passing affair. Not an illusion, but something temporary, both for the prodigies and the mistakes! (Transience is a joke too: look at the way great comics take their exits.)

The buffoon I love most is Juan Calabazas. Juan the Pumpkin. He's not one of the dwarfs, he's the one who squints. There are two portraits of him. In one he's standing, and holding at arm's length, mockingly, a painted, miniature medallion portrait, whilst in his other hand he's holding a mysterious object which commentators haven't exactly identified – it's thought to be part of some kind of grinding machine and is probably an allusion (like 'with a screw loose') to his being a simpleton, as was also, of course, his nickname Pumpkin. In this canvas Velázquez, the master conjuror and portrait painter, colludes with the Pumpkin's joke: How long do you really think looks last?

In the second, later portrait of Juan the Pumpkin, he's squatting

on the floor so he's the height of a dwarf and he is laughing and speaking and his hands are eloquent. I look into his eyes.

They are unexpectedly still. His whole face is flickering with laughter – either his own or the laughter he's provoking, but in his eyes there's no flicker; they are impassive and still. And this isn't the consequence of his squint, because the gaze of the other buffoons, I suddenly realise, is similar. The various expressions of their eyes all contain a comparable stillness, which is exterior to the duration of the rest.

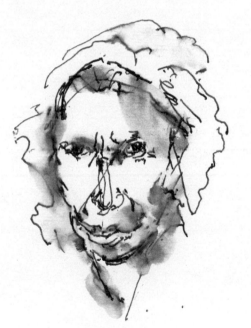

From Géricault

This might suggest a profound solitude, but with the buffoons it doesn't. The mad can have a fixed look in their eyes because they are lost in time, unable to recognise any reference point. Géricault, in his piteous portrait of the mad woman in the Paris hospital of La Salpêtrière (painted in 1819 or 1820), revealed this haggard look of absence, the gaze of someone banished from duration.

The buffoons painted by Velázquez are as far away as the woman in La Salpêtrière from the normal portraits of honour and rank; but they are different, for they are not lost and they have not been banished. They simply find themselves – after the laughter – beyond the transient.

Juan the Pumpkin's still eyes look at the parade of life and at us through a peephole from eternity. This is the secret that a meeting in the Rambla suggested to me.

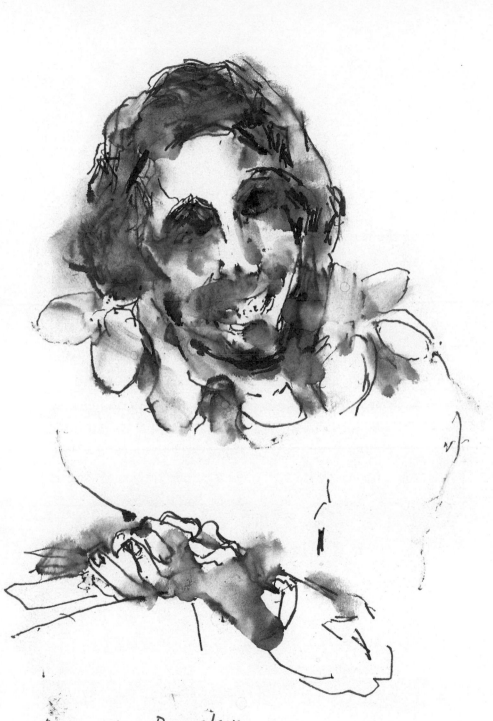

Juan the Pumpkin

It is of the nature of reason to perceive things under a certain species of eternity.

It is of the nature of reason to regard things not as contingent, but as necessary. It perceives this necessity of things truly, that is, as it is in itself. But this necessity of things is the necessity itself of the eternal nature of God. Therefore it is the nature of reason to regard things under this species of eternity. Add to this that the bases of reason are the notions which explain those things which are common to all, and which explain the essence of no particular thing: and which therefore must be conceived without any relation of time, but under a certain species of eternity.

(*Ethics*, Part II, Proposition XLIV)

A dead badger by the side of the road. Yves found her in the snow, frozen. Yes, she's a female.

It must be noted here, that I understand the body to suffer death when its parts are so disposed that they assume one with the other another proportion of motion and rest.

(*Ethics*, Part IV, Proposition XXXIX)

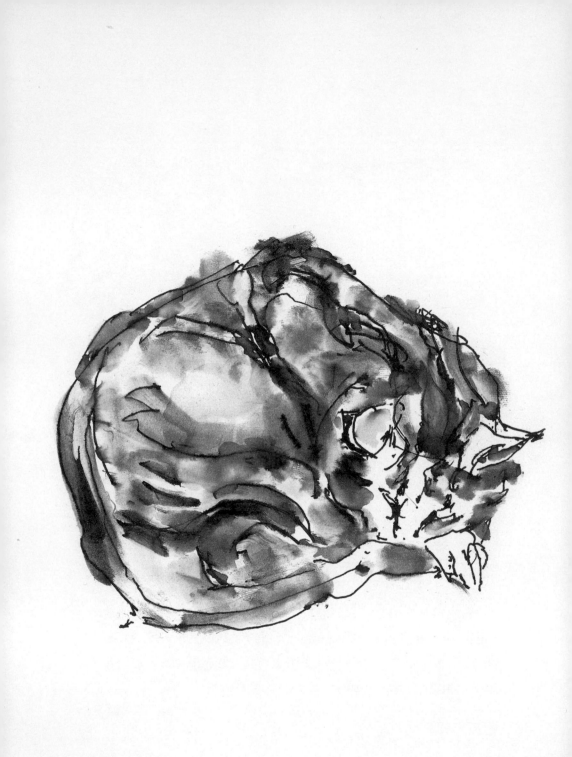

I'm in a hard-discount supermarket, belonging to one of the biggest chains of food retailers in Europe. They run over 8,000 stores. You can buy products here – cartons of apple juice, for example – at half the price you pay elsewhere in other supermarkets. It's situated in a zone where the autoroutes begin, on the outskirts of this city.

About sixty people work here and there are at least as many surveillance cameras. None of the goods are on display. They are in cases with the sides ripped off. Most of the customers are regular and know their way about.

Among them are the elderly poor buying for themselves alone and many young women shopping for the children, the partner (if there is one), themselves, their dependants. Everyone, according to their means, buys to the maximum, because they don't want to come here more than once – or at the most twice – a week. The trolleys, queuing up to check out, are stacked high, invariably with several packs of the same dish – macaroni, for instance, or Mexican tortillas or packets of Hachis Parmentier de Boeuf. A few of the elderly pay cash; everyone else uses credit cards. Anxiously, because it is near the end of the month.

Nobody – except the occasional kid – talks. We are all – customers and staff – suspect and our every move is being watched. We are all picking up, pushing trolleys, scanning, tapping in codes, controlling, weighing vegetables, keeping to schedules, calculating, in a vast hangar whose obsession is Theft.

It's the opposite of a street market, where the key secret is that of a bargain. In a street market everyone encourages everyone to believe they've just made a smart deal; here, every one of us is being considered as a potential thief.

There's little free space – the pallets of goods take up most of it – and the trolleys queuing before the pay counters form a tight line. Two trolleys ahead of me there's a pregnant woman. Tall with loose fair hair. She might be Polish. I doubt whether the child she's awaiting is her first-born. She's frowning as she deposits her purchases on the conveyor belt.

What are the modes of theft which preoccupy – to the exclusion of nearly all other considerations – this hard-discount hangar we are in?

Theft by shoppers. From time to time the firm sends 'mystery shoppers' into the store. Their task is to lift and sneak out a number of items and thus to test the vigilance of the cashiers. Theft by their employees who, if they purchase for themselves anything from the shelves, are required to have a chit, signed by the manager, and are liable at any time to be body searched. Systematic theft by the firm of unpaid working hours from those it employs. Cashiers are forced to put in at least two hours' unpaid work per week. Often more. During their time off, many employees – from the rank of manager downwards – are obliged to be on call night and day in case they are needed in an emergency. No sick leave allowed. No legally prescribed pauses between shifts or prescribed days of rest during a week. Theft of workers' rights. Finally the theft by agro-business corporations, closely linked to global food retailers, of the initiatives once taken by those who worked the land: decisions about crops, varieties, seeds, fertilisers, the species of animals to breed, etc. Once these were local, pragmatic decisions;

today the corporations supply the producers and dictate what is to be produced. Global agriculture is becoming prepackaged – with the aim of turning the whole of nature into a commodity.

The pregnant woman whom I think may be Polish is at the head of the queue. The prescribed target for cashiers is to scan thirty-five items per minute! None can achieve it. Consequently they all have minus marks on their performance records. The pregnant woman, ready to pay, scowls at her credit card.

Then she looks up and clearly sees somebody whom she recognises in the queue behind me. Maybe they came here together. Maybe they planned to come and shop here at the same time today.

Out of a strange discretion I don't look round to observe whom she has seen. My guess is that he's not a man. I think she's a woman. The Pole lifts her head, shakes back her hair and smiles in such a way that I conclude this.

Then she goes on smiling and smiling.

Her smile is an expression of pure happiness. It radiates and absorbs at the same time. Like any sudden happiness it was unforeseeable.

Her smile contains forgotten promises which have for a moment returned to become real.

Am I exaggerating about the promise of her smile or about the thieving hangar? I am not. Both exist. Exist in the same place and at the same moment.

Desire which arises from pleasure is stronger, *caeteris paribus*, than the desire which arises from pain.

(*Ethics*, Part IV, Proposition XVIII)

Each spring when the irises begin to flower, I find myself drawing them – as if obeying an order. There's no other flower so commanding. And this may have something to do with the way they open their petals, already printed. Irises open like books. At the same time, they are the smallest, tectonic quintessence of architecture. I think of the Mosque Suleiman in Istanbul. Irises are like prophesies: simultaneously astounding and calm.

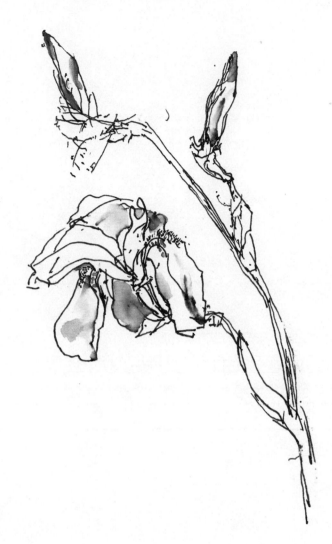

... all things in nature proceed eternally from a certain neces-
sity and with the utmost perfection. I should add, however, this
further point: that the doctrine of final causes turns nature upside
down entirely. For that which in truth is a cause it considers
as an effect, and vice versa, and so it makes that which is first
by nature to be last, and again, that which is highest and most
perfect it renders imperfect.

(*Ethics*, Part I, Appendix)

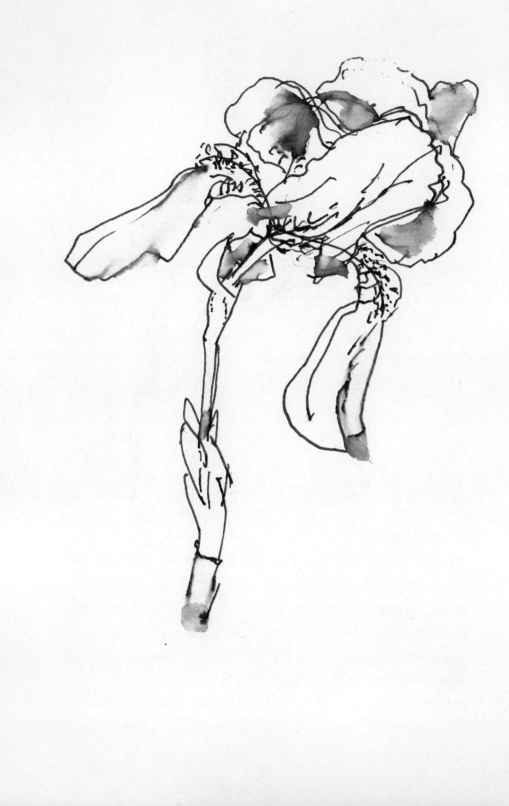

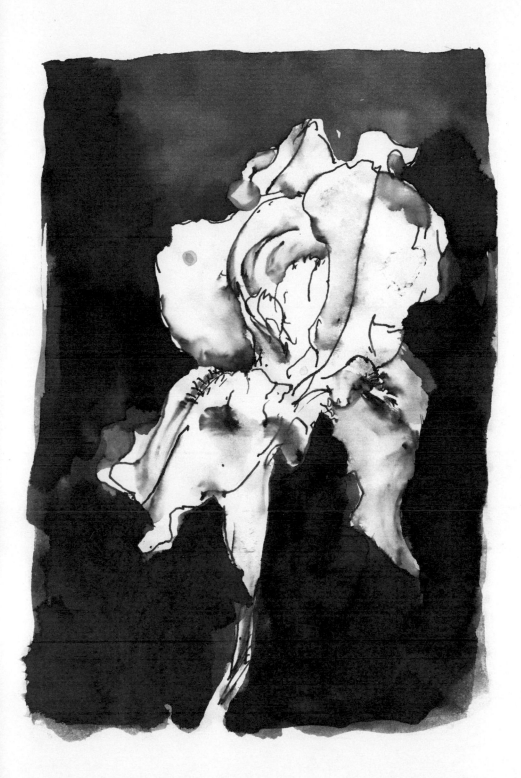

Coming for a ride, Bento?

I wouldn't make a direct comparison between a motorbike and a telescope for which you grind lenses, yet they have certain features in common: both need to be well aimed, both diminish distance, and both offer a tunnel of attention and the sensation of speed.

When you stop looking through a telescope, even if you're looking at a coastline or a stationary star, when you stop looking through the lens, you have the impression of your vision slowing down. In the tunnel of speed there is also a kind of silence, and when you get off the bike or remove your eye from the eyepiece, all the slow repetitive sounds of daily life return, and this silence recedes.

> ... surely human affairs would be far happier if the power in
> men to be silent were the same as that to speak.
>
> (*Ethics*, Part III, Propositions)

To the key-ring of my motorbike ignition key I've attached a little token of a black tortoise. This model of bike (a Honda CBR 1100) was known, when first launched, as Blackbird. The tortoise with his determined slowness and the swiftness of the blackbird's flying.

For many years I've been fascinated by a certain parallel between the act of piloting a bike and the act of drawing. The parallel fascinates me because it may reveal a secret. About what? About displacement and vision. Looking brings closer.

Put in ignition key, swing leg over, fasten helmet strap, pull on gloves, adjust choke, press starter, kick back the stand with left foot.

I remember when bikes had only kick-starters. Lunge, lunge with right leg, using as much bodyweight as one could muster. Cylinders inhaling, coughing, not firing. When they do finally spark into life, the sensation is of being astride a chorale.

Let out clutch gently with left hand, palm throttle with right, move forward. Stability.

You pilot a bike with your eyes, with your wrists and with the leaning of your body. Your eyes are the most importunate of the three. The bike follows and veers towards whatever they are fixed on. It pursues your gaze, not your ideas. No four-wheeled-vehicle driver can imagine this.

If you look hard at an obstacle you want to avoid, there's a grave risk that you'll hit it. Look calmly at a way around it and the bike will take that path.

I say expressly that the mind has no adequate but only confused knowledge of itself, of its body, and of external bodies, when it perceives a thing in the common order of nature, that is, whenever it is determined externally, that is by fortuitous circumstances, to contemplate this or that, and not when it is determined internally, that is, by the fact that it regards many things at once, to understand their agreements, differences and oppositions one to another.

(*Ethics*, Part II, Proposition XXIX)

Pilot and two-wheeled machine form a single unit, and its disposition from within, its capacity for self-regulation, is linked to the inertia principle in physics. Like a top spinning, it continues and corrects itself so long as a certain momentum is maintained. But

unlike a top spinning, which remains on one spot, this unit traces a continually shifting, ongoing line which feels like a contour. A contour of what? Of what is extensive. Exactly as you describe it.

> Before we proceed further, let us call to mind what we have already shown: that whatever can be conceived by infinite intellect as constituting the essence of substance, appertains to one substance alone: and consequently thinking substance and extended substance are one and the same substance, which is now comprehended through this and now through that attribute.
>
> (*Ethics*, Part 2, Proposition VII)

The contours of what is extensive.

The act of drawing. Any fixed contour is in nature arbitrary and impermanent. What is on either side of it tries to shift it by pushing or pulling. What's on one side of a contour has got its tongue in the mouth of what's on the other side. And vice versa. The challenge of drawing is to show this, to make visible on the paper or drawing surface not only discrete, recognisable things, but also to show how the extensive is one substance. And, being one substance, it harasses the act of drawing. If the lines of a drawing don't convey this harassment the drawing remains a mere sign.

The lines of a sign are uniform and regular: the lines of a drawing are harassed and tense. Somebody making a sign repeats an habitual gesture. Somebody making a drawing is alone in the infinitely extensive.

Think of the bike's trajectory or track as if it were a line drawn on the ground. The pilot with his body is concentrated on maintaining that line. The bike may follow his gaze, but he has to keep them both on the ground. And to do this he has continually to

negotiate with two things. (1) The contact between the ground's surface and the tyres of the two revolving wheels. And (2) the impetus of the forces brought into play when the line and the bike change direction. Unless you are driving alone on a race track straight lines are brief. You are seldom vertical. To varying degrees you are nearly always heeling over, and, according to the degree, you negotiate with the play of forces involved.

(1) When as a draughtsman your drawing instrument makes contact with the paper, you assess how absorbent the paper is, how smooth, how resistant, how accommodating or intractable, and then you draw accordingly, modifying pressure, the longevity of touches, the amount of ink, the hardness of the charcoal, the amount of spit, etc. And as a pilot, you observe and assess the surface of the road or track in a comparable manner. Gravel, sand, moisture, fallen leaves, oil, white marking-paint, mud, ice, encourage, each in its own way, the tyres to slip. Other surfaces hold the tyres. And you decide accordingly about the instant of each of your own actions, which involve braking, accelerating, turning, slowing down. You react as though you have a bare foot which feels the tread of the tyres on the surface they are crossing.

(2) When you change direction you lean into the turn, and this maintains the turning. At the same moment, however, you coax the front wheel to point in the opposite direction, to point out of the turn. And you do this not to limit or end the turn, but to strengthen the forward thrust coming from the back wheel and to keep the line being drawn taut and tense, to keep it under a constant push-and-pull pressure from left and right, from the extensive which it is crossing. What is one side of the line you are following has got its tongue in the mouth of what is on its other side.

Right-hand corner

Axiom I. All bodies are either moving or at rest.

Axiom II. Each body moves now more slowly, now more quickly.

Lemma I. Bodies are reciprocally distinguished with respect to motion or rest, quickness or slowness, and not with respect to substance.

. . . Lemma III. A body in motion or at rest must be determined to motion or rest by some other body, which, likewise, was determined for motion or rest by some other body, and this by a third, and so on to infinity.

<div align="right">(Ethics, Part II, Proposition XIII, Note)</div>

You are riding a drawing.

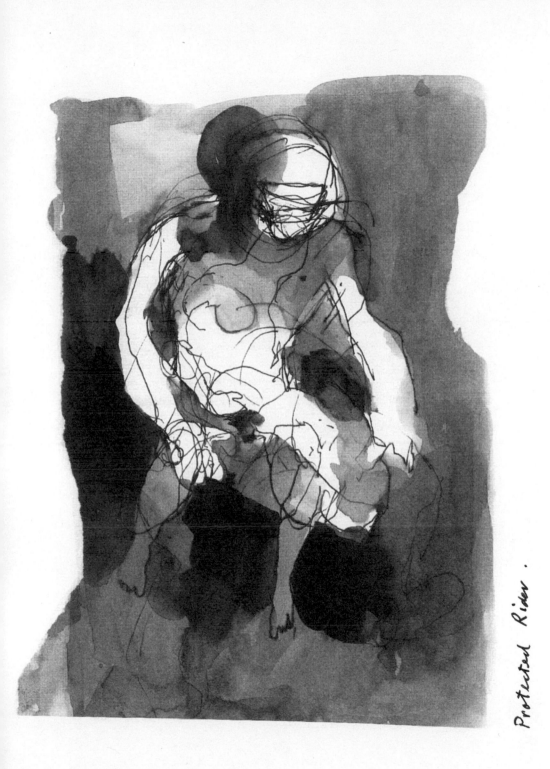

Protected Rider.

Spontaneously, I always want to draw on the right-hand page of the sketchbook, rather than the left. A recollection from child-hood, a question of hope?

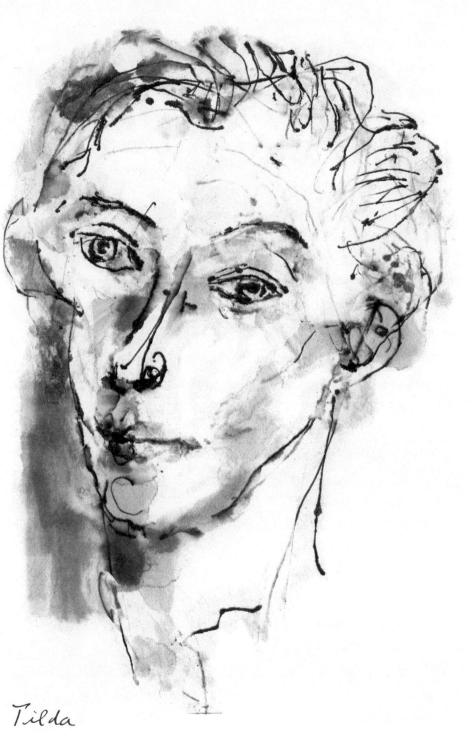

Tilda

I want to tell you the story of how I gave away a *Sho* Japanese brush. Where it happened and how. The brush had been given to me by an actor friend who had gone to work for a while with some Noh performers in Japan.

I drew often with it. It was made of the hairs of horse and sheep. These hairs once grew out of a skin. Maybe this is why when gathered together into a brush with a bamboo handle they transmit sensations so vividly. When I drew with it I had the impression that it and my fingers, loosely holding it, were touching not paper but a skin. The notion that a paper being drawn on is like a skin is there in the very word: brushstroke. The one and only touch of the brush! as the great draughtsman Shitao termed it.

The setting for the story was a municipal swimming pool in a popular, though not chic, Paris suburb, where from time to time I was something of an habitué. I went there every day at one p.m. when most people were eating and so the pool was less crowded.

The building is long and squat and its walls are of glass and brick. It was built in the late 1960s and it opened in 1971. It's situated in a small park where there are a few silver birches and weeping willows.

From the pool when swimming you can see the willows high up through the glass walls. The ceiling above the pool is panelled and now, forty years later, several of the panels are missing. How many times when swimming on my back have I noticed this, whilst being aware of the water holding up both me and whatever story I'm puzzling over?

There's an eighteenth-century drawing by Huang Shen of a cicada singing on the branch of a weeping willow. Each leaf in it is a single brushstroke.

Seen from the outside it's an urban, not a rural building, and if you didn't know it was a swimming pool and you forgot about the trees, you might suppose it was some kind of railway building, a cleaning shed for coaches, a loading bay.

There's nothing written above the entrance, just a small blazon containing the three colours of the tricolore, emblem of the Republic. The entrance doors are of glass with the instruction 'POUSSEZ' stencilled on them.

When you push one of these doors open and step inside you are in another realm which has little to do with the streets outside, the parked cars or the shopping street.

The air smells slightly of chlorine. Everything is lit from below rather than from above as a consequence of the light reflected off the water of the two pools. The acoustics are distinct: every sound has its slight echo. Everywhere the horizontal, as distinct from the vertical, dominates. Most people are swimming, swimming from one end of the large pool to the other, length after length. Those standing have just taken off their clothes or are getting out of them so there's little sense of rank or hierarchy. Instead, everywhere, there's this sense of an odd horizontal equality.

There are many printed notices, all of them employing a distinctive bureaucratic syntax and vocabulary.

The Hairdryer will be shut off 5 minutes before closing-time.

Bathing Caps Obligatory. Council Decree. As from Monday Sept. 12 1980.

Entry through this door forbidden to any person who is not a member of staff. Thank you.

The voice embodied in such announcements is inseparable from the long political struggle during the Third Republic for the recognition of citizens' rights and duties. A measured, impersonal committee voice – with somewhere in the distance a child laughing.

Around 1950 Fernand Léger painted a series of canvasses called *Plongeurs* – Divers in a swimming pool. With their primary colours and their relaxed, simple outlines, these paintings celebrated the dream and the plan of workers enjoying leisure and, because they were workers, transforming leisure into something which had not yet been named.

Today the realisation of this dream is further away than ever. Yet sometimes, whilst putting my clothes in a locker in the men's changing room and attaching the key to my wrist, and taking the obligatory hot shower before walking through the foot bath, and going to the edge of the large pool and diving in, I remember these paintings.

Most of the swimmers wear, as well as the obligatory bathing caps, dark goggles to protect their eyes from the chlorine. There's little eye contact between us, and if a swimmer's foot accidentally touches another swimmer, he or she immediately apologises. The atmosphere is not that of the Côte d'Azur. Here each one privately pursues her or his own target.

I first noticed her because she swam differently. The movements of her arms and legs were curiously slow – like those of a frog – and at the same time her speed was not dramatically reduced. She had a different relationship to the element of water.

The Chinese master Qi Baishe (1863–1957) loved drawing frogs, and he made the tops of their heads very black, as if they

were wearing bathing caps. In the Far East the frog is a symbol of freedom.

Her bathing cap was ginger-coloured and she was wearing a costume with a floral pattern, a little like English chintz. She was in her late fifties and I assumed was Vietnamese. Later I discovered my mistake. She is Cambodian.

Every day she swam, length after length, for almost an hour. As I did too. When she decided it was time to climb up one of the corner ladders and leave the pool, a man, who was himself swimming several tracks away, came to help her. He was also Southeast Asian, a little thinner than her, a little shorter, with a face that was more carved than hers; her face was moonlike.

He came up behind her in the water and put his hands under her arse so that she, facing the edge of the pool, sat on them and he bore a little of her weight when they climbed out together.

Once on the solid floor she walked away from the corner of the pool towards the foot bath and the entrance to the women's changing room, alone and without any discernible limp. Having noticed this ritual a number of times I could see, however, that, when walking, her body was taut, as if stretched on tenterhooks.

The man with the brave, carved face was presumably her husband. I don't know why I had a slight doubt about this. Was it his deference? Or her aloofness?

When she first came into the pool and wanted to enter the water, he would climb halfway down the ladder and she would sit on one of his shoulders and then he would prudently descend until the water was over his hips and she could launch herself to swim away.

Both of them knew these rituals of immersion and extraction by heart and perhaps both recognised that in the ritual the water

played a more important role than either of them. This might explain why they appeared more like fellow-performers than man and wife.

Time went by. The days passed repetitively. Eventually when she and I, swimming our lengths, crossed one another going in opposite directions, for the first time on that day, with only a metre or two between us, we lifted our heads and nodded at one another. And when, about to leave the pool, we crossed for the last time that day, we signalled 'au revoir'.

How to describe that particular signal? It involves raising the eyebrows, tossing the head as if to throw back the hair and then screwing up the eyes in a smile. Very discreetly. Goggles pushed up onto the bathing cap.

One day whilst I was taking a hot shower after my swim — there are eight showers for men, and to switch one on, there are no taps, you press an old-fashioned button like a doorknob, and the trick is that amongst the eight there's some variation in the duration of the flow of hot water until the button has to be pressed again, so by now I knew exactly which shower had the hot jet that lasted longest, and, if it was free, I always chose it — one day whilst I was taking a hot shower after my swim the man from Southeast Asia came under the shower next to mine and we shook hands.

Afterwards we exchanged a few words and agreed to meet outside in the little park after we'd dressed. And this is what we did and his wife joined us.

It was then I learnt they were from Cambodia. She is very distantly related to the family of the famous King and then Prince Sihanouk. She had fled to Europe when she was twenty, in the mid-1970s. Prior to that she had studied art in Phnom Penh.

It was she who talked and I who asked the questions. Again I had the impression that his role was that of a bodyguard or assistant. We were standing near the birch trees beside their parked two-seater Citroën C15 with a seatless space behind. A vehicle much the worse for wear. Do you still paint? I asked. She lifted her left hand into the air making a gesture of releasing a bird, and nodded. Often she's in pain, he said. I read a lot too, she added, in Khmer and in Chinese. Then he indicated it was perhaps time for them to climb into their C15. I noticed, hanging from the rearview mirror above the windscreen, a tiny Buddhist Dharma wheel, like a ship's helm in miniature.

After they had driven off I lay on the grass – it was the month of May – beneath the weeping willows and found myself thinking about pain. She'd left Cambodia – still then Kampuchea – in the year when Sihanouk had been ousted with the probable help of the CIA, and when the Khmer Rouge under Pol Pot had taken over the capital and were beginning the enforced deportation of its 2 million inhabitants to the countryside, where living in communities with no individual property, they had to learn to become New Khmers! A million of them didn't survive. In the preceding years Phnom Penh and its surrounding villages had been systematically bombarded by USA B-52 bombers. At least a hundred thousand people died.

The Kampuchean people, with their mighty past of Angkhor Wat and its massive, painless stone statues, which later were cracked open and marauded by something which has come to look today like suffering, the Kampuchean people were, at the moment she left her country, surrounded by enemies – Vietnamese, Laotians, Thais – and were on the point of being tyrannised and massacred by their own political visionaries, who transformed themselves into fanatics so that they could inflict vengeance on reality itself,

so they could reduce reality to a single dimension. Such reduction brings with it as many pains as there are cells in a heart.

Gazing at the willows, I watched their leaves trailing in the wind. Each leaf a small brushstroke. I found it impossible to separate the pain to which her body was apparently heir from the pain of her country's history during the last half century.

Today Cambodia is the poorest country in Southeast Asia and 90 per cent of its exports are manufactured in sweatshops producing pieces of garments for the brand-name rag-trade multinationals of the West.

A group of four-year-old kids ran past me up the steps and through the glass doors – going to their swimming lessons.

The next time I saw her and her husband in the pool I approached her when she had finished one of her lengths, and asked if she could tell me what it was that caused her pain. She answered immediately as if naming a place: Polyarthritis. It came when I was young, when I knew I had to leave. It's kind of you to ask.

The left half of her forehead is a little discoloured, browner than the rest, as if the leaf of a frond, once placed on her skin there, had slightly stained it. When her head is thrown back floating on the water and her face looks moonlike, you could compare this little discolouring with one of the 'seas' on the surface of the moon.

We both trod water and she smiled. When I'm in water, she said, I weigh less and after a little while my joints stop hurting.

I nodded. And then we went on swimming. Swimming on her front, as I have said, she moved her legs and arms as slowly as a frog sometimes does. On her back she swam like an otter.

Cambodia is a land with an unique, osmotic relationship with fresh water. The Khmer word for homeland is *Teuk-Dey*, which means Water-Land. Framed by mountains, Cambodia's flat,

horizontal, alluvial plain – about a fifth of the size of France – is crossed by six rivers, including the vast Mekong. During and after the summer monsoon rains, the flow of this river multiplies by fifty! And in Phnom Penh, at the head of its delta, the river's level rises systematically by eight metres. At the same time, to the north, the lake of Tonlé Sap overflows each summer to four times its 'normal' winter size to become an immense reservoir, and the river of Tonlé Sap turns round to run in the opposite direction, its downstream becoming upstream.

Small wonder then that this plain offered the most varied and abundant freshwater fishing in the world, and that for centuries its peasants lived off rice and the fish of these waters.

It was on that day whilst swimming during the lunch hour at the municipal swimming pool, after she had said the word Polyarthritis, pronouncing it as if it were a place, that I thought of giving her my *Sho* brush.

The same evening I put it into a box and wrapped it. And each time I went to the pool I took it with me until they turned up again. Then I placed the little box on one of the benches behind the diving boards and told her husband so he could pick it up when they left. I left before they did.

Months passed without my seeing them because I was elsewhere. When I returned to the pool I looked for them and could not see them. I adjusted my goggles and dived in. Several kids were jumping in feet first, holding their noses. Others on the edge were adjusting flippers to their feet. It was noisier and more animated than usual because by now it was the month of July; school was over, and the kids whose families couldn't afford to leave Paris were coming to play for hours in the water. The special entrance fee for them was minimal, and the lifesaving swimming instructors maintained an

easy-going discipline. A few regulars, with their strict routines and personal targets, were still there.

I had done about twenty lengths and was about to start another when – to my astonishment – I felt a hand firmly placed from behind on my right shoulder. I turned my head and saw the stained moon-face of the one-time art student from Phnom Penh. She was wearing the same ginger-coloured bathing cap and she was smiling, a wide smile.

You're here!

She nods and whilst we are treading water she comes close and kisses me twice on both cheeks.

Then she asks: Bird or flower?

Bird!

Thereupon she lays her head back on the water and laughs. I wish I could let you hear her laugh. Compared to the splashing and cries of the kids around us, it is low-keyed, slow and persistent. Her face is more moonlike than ever, moonlike and timeless. The laugh of this woman, who will soon be sixty, continues. It is unaccountably the laugh of a child – that same child whom I imagined laughing somewhere behind the committee voices.

A few days later her husband swims towards me, asks after my health, and whispers: On the bench by the diving boards. Then they leave the pool. He comes up behind her, puts his hands under her arse, and she, facing the edge of the pool, sits on them whilst he bears a little of her weight and they climb up and out together.

Neither of them wave back to me as they have on other occasions. A question of modesty. Gestural modesty. No gift can be accompanied by a claim.

On the bench is a large envelope which I take. Inside is a painting on rice paper. The painting of the bird I chose when she asked

me what I wanted. The painting shows a bamboo and perched on one of its stems a blue tit. The bamboo is drawn according to all the rules of the art. A single brushstroke beginning at the top of the stalk, stopping at each section, descending and becoming slightly wider. The branches, narrow as matches, drawn with the tip of the brush. The dark leaves rendered in single strokes like darting fish. And lastly the horizontal nodes, brushed from left to right, between each section of the hollow stalk.

The bird with its blue cap, its yellow breast, its greyish tail and its claws like the letter W, from which it can hang upside down when necessary, is depicted differently. Whereas the bamboo is liquid, the bird looks embroidered, its colours applied with a brush as pointed as a needle.

Together, on the surface of the rice paper, bamboo and bird have the elegance of a single image, with the discreet stencil of the artist's name stamped below and to the left of the bird. Her name is L——.

When you enter the drawing, however, and let its air touch the back of your head, you sense how this bird is homeless. Inexplicably homeless.

I framed the drawing like a scroll, without a mount, and with great pleasure chose a place to hang it. Then one day, many months later, I needed to look up something in one of the Larousse illustrated encyclopaedias. And turning the pages I happened to fall upon the little illustration it contained of a *mésange bleue* (blue tit). I was puzzled. It looked oddly familiar. Then I realised that, in this standard encyclopaedia I was looking at the model – the two W's of the blue tit's claws were, for instance, at precisely the same angle, as were also the head and beak – the exact model which L—— had taken for the bird perched on the bamboo.

And again I understood a little more about homelessness.

But it is appropriate here to note that we can only distinctly imagine distance of time, like that of space, up to a certain limit, that is, just as those things which are beyond two hundred feet from us, or, whose distance from the place where we are exceeds that which we can distinctly imagine, we are wont to imagine equally distant from us and if they were in the same plane, so also those objects whose time of existing we imagine to be distant from the present by a longer interval than that which we are accustomed to imagine, we imagine all to be equally distant from the present, and refer them all as it were to one moment of time.

(*Ethics*, Part IV, Definitions VI)

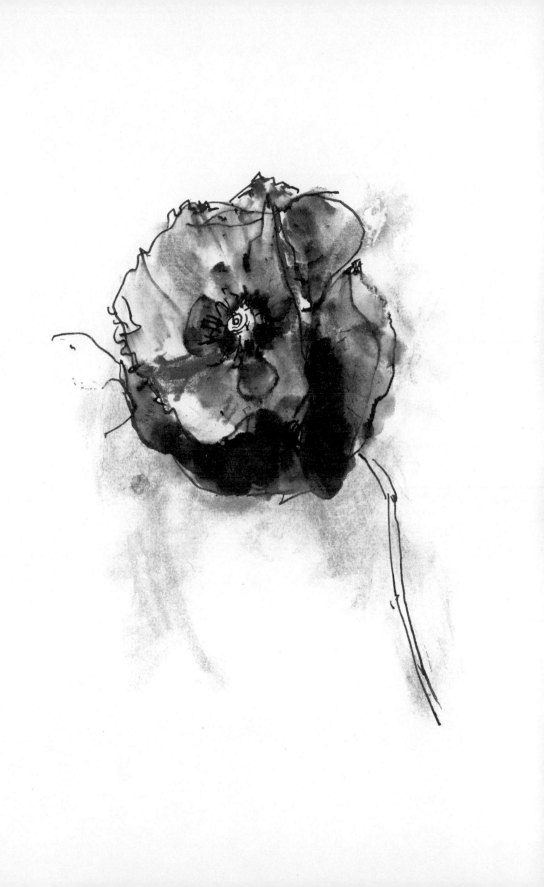

All things depend on the power of God. That things should be
different from what they are must involve a change in the will
of God, but the will of God cannot change (as we have most
clearly shown from the perfection of God): therefore things
could not be otherwise than as they are. I confess that the theory
which subjects all things to the will of an indifferent God and
makes them dependent on his pleasure is far nearer the truth
than that which states that God acts in all things for the further-
ing of good.

(*Ethics*, Part I, Proposition XXXIII, Note II)

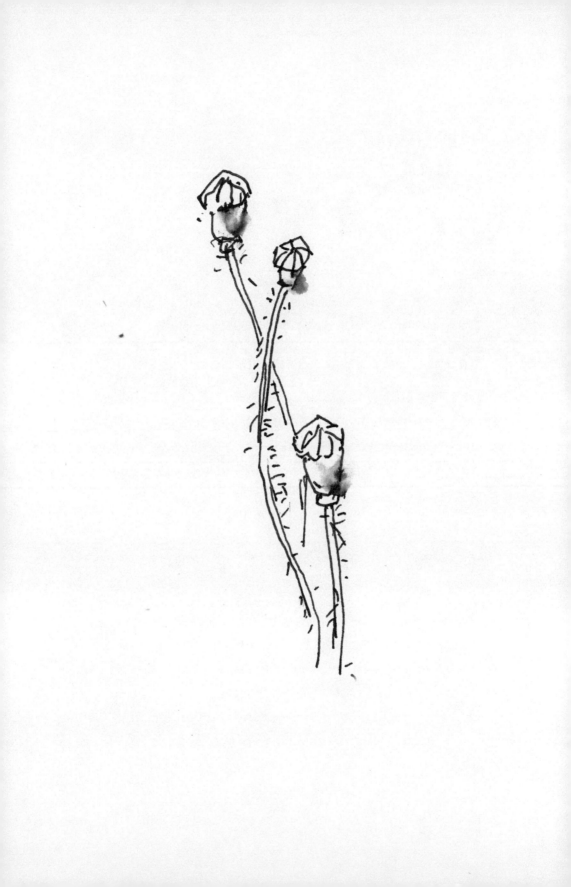

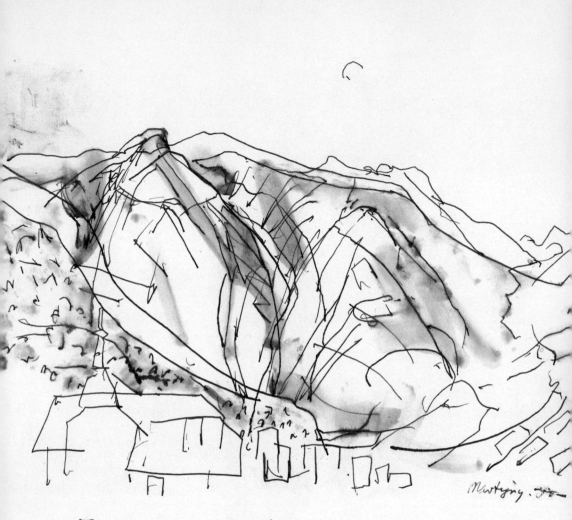

The Alps at Martigny

Existence appertains to the nature of substance.

A substance cannot be produced from anything else: it will therefore be its own cause, that is its essence necessarily involves existence, or, existence appertains to its nature.

(*Ethics*, Part I, Proposition VII, Proof)

Sandstone rose from Algerian desert

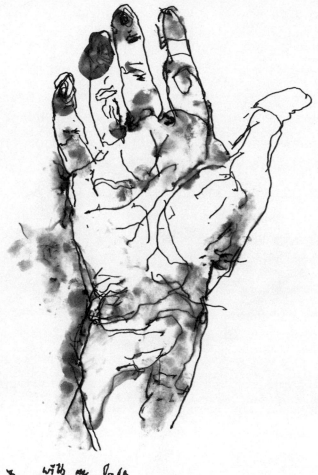

with my left
drawing hand of my right hand

I live in a state of habitual confusion. By confronting the confusion I sometimes achieve a certain lucidity. You showed us how to do this.

But human power is considerably limited and infinitely surpassed by the power of external causes, and therefore we do not have an absolute power of adapting things which are outside us for our use. But we shall bear with equanimity those things which happen to us contrary to that which a regard for our advantage postulates, if we are conscious that we have done that which we ought, and that we could not have extended the power we have to such an extent as to avoid those things, and moreover, that we are part of nature as a whole, whose order we follow. If we understand this clearly and distinctly, that part of us which is defined by our understanding, that is, the best part of us, will be wholly contented, and will endeavour to persist in that contentment. For in so far as we understand, we can desire nothing save that which is necessary, nor can we absolutely be contented with anything save what is true: and therefore in so far as we understand this rightly, the endeavour of the best part of us agrees with the order of the whole of nature.

(*Ethics*, Part IV, Appendix, Paragraph 32)

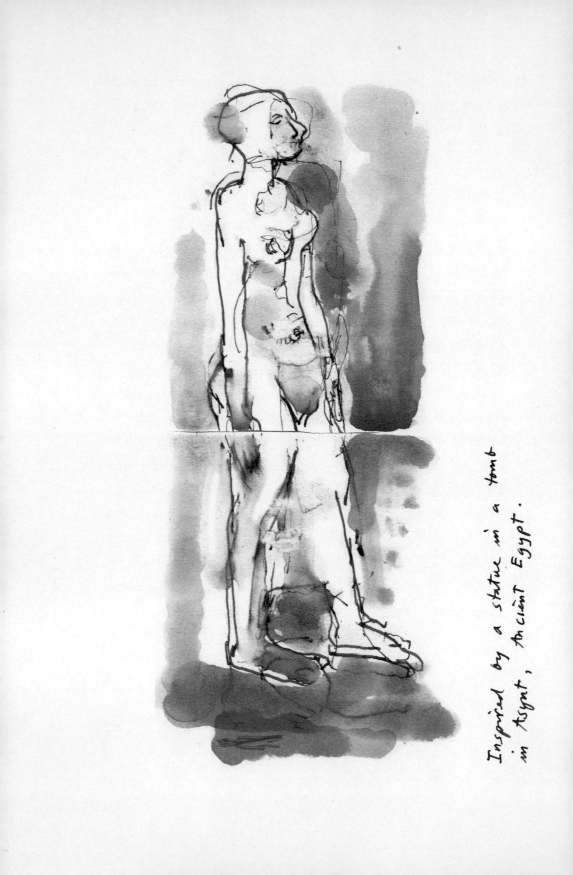

Inspired by a statue in a tomb
in Asyut, Ancient Egypt.

The human body (*corpus humanum*) is composed of many individuals (of different nature), each one of which is highly composite.

The individuals of which the human body is composed are some fluid, some soft and some hard.

The individuals composing the human body, and consequently the human body itself is affected in many ways by external bodies.

The human body needs for its preservation many other bodies from which it is, so to speak, continually regenerated.

When a fluid part of the human body is so determined by an external body that it impinges frequently on another part which is soft, it changes its surface and as it were imprints on it the traces of the external impelling body.

The human body can move external bodies in many ways, and dispose them in many ways.

The human mind is apt for perceiving many things, and more so according as its body can be disposed in more ways.

(*Ethics*, Part II, Postulates I–VI, Proposition XIV)

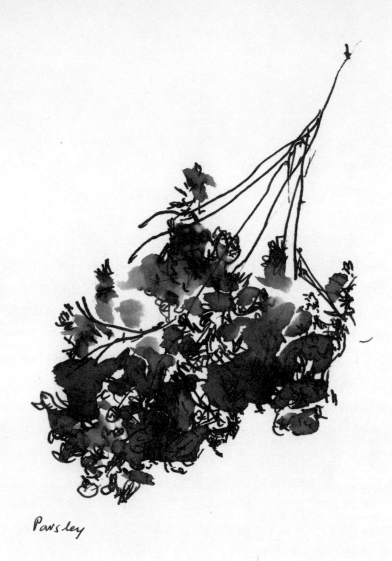

Parsley

That which is common to and a property of the human body, and certain external bodies by which the human body is used to be affected, and which is equally in the part and whole of these, has an adequate idea in the mind.

Hence it follows that the mind is the more apt for perceiving many things adequately, the more its body has things in common with other bodies.

(*Ethics*, Part II, Proposition XXXIX, Corollary)

142

Olive tree, Aein Kmiya, Palestine

Before you began grinding lenses, you and your brother Gabriel helped your father in his business in Amsterdam, selling olive oil and dried fruit imported from Portugal, from where your father had emigrated. After his death you both took over the business but within two years it went bankrupt, and you moved to Vlooienburg, another district in the city where you learnt the craft of lens-grinding and polishing.

Dried fig

...money has provided a short way to all these things, whence it has come about that the image of money occupies the principal place in the mind of the vulgar, for they can scarcely imagine any pleasure unless it be accompanied with the idea of money as the cause.

But this vice is only theirs who seek to acquire money, not from any need nor by reason of necessity, but because they have learned the arts of gain wherewith to raise themselves to a splendid state. They feed their bodies of course according to custom, but sparingly, for they think they lose as much of their goods as they spend on the conservation of their body...

(*Ethics*, Part IX, Propositions XXVIII & XXIX)

Study the faces of the new tyrants. I hesitate to call them plutocrats for the term is too historical and these men belong to a phenomenon which is unprecedented. Let's settle for profiteers. Their profiteer faces have many features in common. This conformity is partly circumstantial – they possess similar talents and they live according to similar routines – and partly it is chosen as a style.

My diagram is based on men from the North. Obviously a portrait of a profiteer from the South would be different, yet I suspect the same tendencies would be apparent.

Their ages vary but the style is that of men in their late forties. They are impeccably dressed and their tailoring is reassuring,

like the silhouette of high-security delivery vans. Armor Mobile Security.

Studying their features you have the impression that they have no pronounced, let alone excessive, physical appetites – apart from an insatiable appetite for control. Far from looking monstrous, their faces, although somewhat strained, seem almost bland.

They have foreheads with many horizontal creases. Not furrows ploughed by thought but rather lines of incessant passing information.

Small, swift eyes which examine everything and contemplate nothing. Ears extensive as a database, but incapable of listening.

Lips which seldom tremble, and mouths which take decisions implacably.

They gesture a lot with their hands, and with their hands they demonstrate formulae and do not touch experience.

Their heads of hair, meticulously arranged as if for an aeronautic velocity test.

The assured confidence visible in their faces matches their ignorance, which is also visible.

You described how there are three forms of knowledge. A haphazard form based on hearsay and impressions and never related to any whole. A knowledge, using adequate ideas, concerning the properties of things. And thirdly, a knowledge concerning the essence of things which add up to God.

The profiteers know nothing, but nothing, about either the properties or the essence of things. They are familiar only with their own impressions of their own rackets. Hence their paranoia and, generated by the paranoia, their repetitive energy. Their repeated article of faith is: There is no alternative.

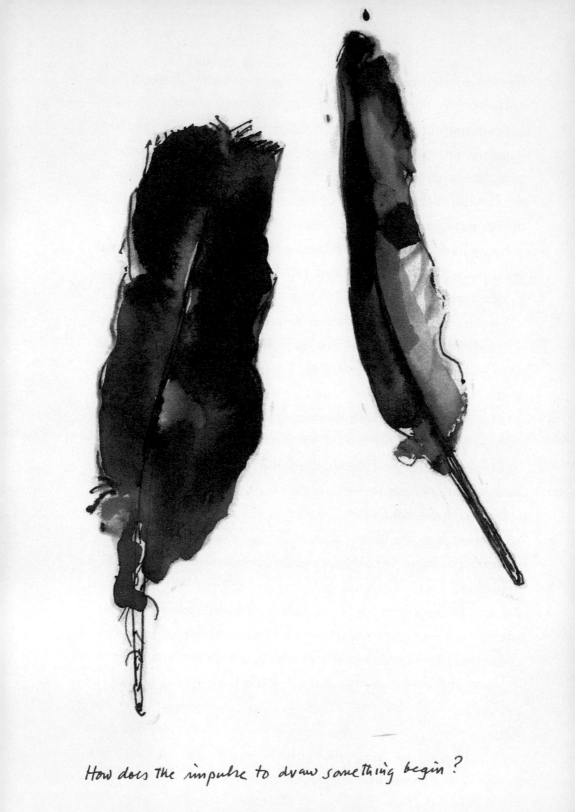

How does the impulse to draw something begin?

When I'm drawing — and here drawing is very different from writing or reasoning — I have the impression at certain moments of participating in something like a visceral function, such as digestion or sweating, a function that is independent of the conscious will. This impression is exaggerated, but the practice or pursuit of drawing touches, or is touched by, something proto-typical and anterior to logical reasoning.

Thanks to the recent work of neurobiologists like Antonio Damasio, it's now known that the messages which pass from cell to cell in a living body do so in the form of charts and maps. They are spatial arrangements. They have a geometry.

It is through these 'maps' that the body communicates with the brain and the brain with the body. And these messages constitute the basis of the mind, which is the creature of both body and brain, as you believed and foresaw. In the act of drawing there's perhaps an obscure memory of such map-reading.

As Damasio put it: 'The entire fabric of a conscious mind is created from the same cloth — images generated by the brain's map-making abilities.'

Drawing is anyway an exercise in orientation and as such may be compared with other processes of orientation which take place in nature.

When I'm drawing I feel a little closer to the way birds navigate when flying, or to hares finding shelter if pursued, or to fish knowing where to spawn, or trees finding a way to the light, or bees constructing their cells.

Print from cells
in a bee-hive

I'm aware of a distant, silent company. Almost as distant as the stars. Company nevertheless. Not because we are in the same universe, but because we are involved – each according to his own mode – in a comparable manner of searching.

Drawing is a form of probing. And the first generic impulse to draw derives from the human need to search, to plot points, to place things and to place oneself.

To quote Damasio again: '…conscious minds arise from establishing a relationship between the organism and an object-to-be-known.'

The generic impulse being what it may be, what is it that

suddenly prompts us to start a drawing of a particular object? We carry a sketchbook wherever we go. For weeks we don't open it; all the while we are observing things without feeling the compulsion to draw them. And then suddenly it happens. We have to draw this.

It seems to me that, when it occurs, the impulse to draw is generated by a similar movement of the imagination, whatever the circumstances or the object to be drawn.

Of course, every drawing has its own raison d'être and hopes to be unique. For every drawing we start, we have a distinct and different hope. And every drawing fails in its own unforeseeable and particular way. Nevertheless every drawing begins with a similar movement of the imagination.

All aircraft, whatever their power or load or destination, take off from a runway following the same aeronautical routine; otherwise they don't get airborne. And in the same way, all spontaneous (as distinct from ordered) drawings 'take off' and are upheld by a similar imaginative movement.

And it is this movement – which is complex and paradoxical, as are many things which touch our hearts – it's this movement that I want to try to define or describe.

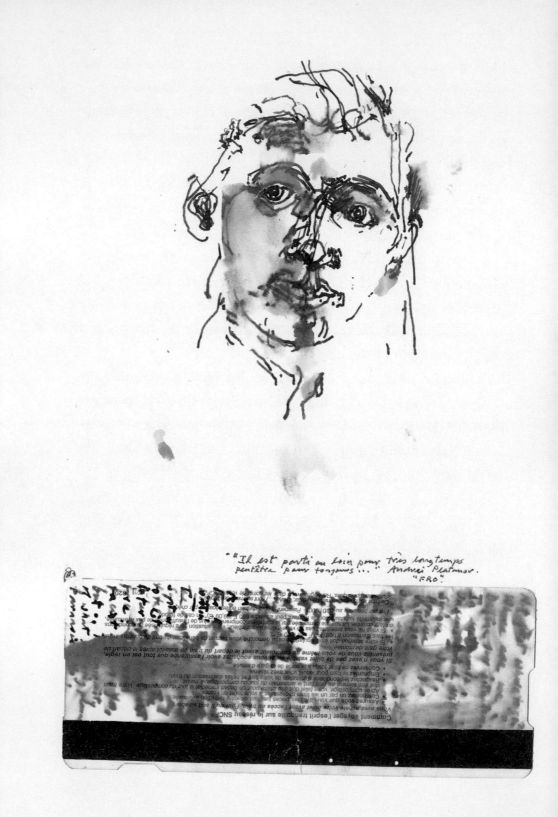

« "Il est parti au loin pour très longtemps
peut-être pour toujours..." Andreï Platonov.
"FRO".

Maybe a drawing I made of the Russian writer Andrei Platonov can help. Platonov was born in 1899 and died in Moscow in 1951. His father was an engine-driver. He himself began working on the railways when he was fifteen. Then he was trained as an engineer specialising in land reclamation, and soon began writing as a journalist about life and events in the remote, immense and often devastated Russian countryside. He witnessed the Civil War, and later the enforced collectivisation of the land and the monstrous famines that followed it. In the Second World War he was a war correspondent at the front. Apart from writing for the press, he also wrote for himself. Stories provoked by what he had witnessed. Stories that implored to be written. Some were published during his lifetime. Most had to wait half a century to be published in Russian after his death, and then to be translated.

I began reading him ten years ago and have come to admire him more and more. He was, in many ways, a precursor of the storytellers of whom the world today has need.

Reading Platonov, I try on occasions to picture him. He never talks about himself directly, but his voice, as he guides us through modern history from one extremity to another, is instantly recognisable, a voice which is passionate and calm, furious and patient.

' "You won't forget me now?" Lyuba asked as she said good-bye.

' "No," said Nikita, "I've no one else to remember." '

I have at hand a number of photos of Platonov. It's easy to picture him. As a child. As a railwayman. As a journalist. As a father. But the photos place him inexorably in the past, whereas his words as I read them or reflect upon them are present and immediate. I want to see him now, beside his book of stories, open on the table in front of me.

In search of this immediacy, I suddenly started to make a drawing of him from one of the photographs. It was taken on his wedding day in 1922.

As I drew I had the impression of making a self-portrait. Not of myself but of him. (We are not alike either physically or psychologically.) It was his voice and the photo which had to lead me to this self-portrait. He's wearing a disused, stripped soldier's tunic. Clothes were in short supply. The word *self* needed to stop being a noun and needed to acquire the drive of the preposition *towards*.

Towards this man who, in face of the famine and drought which accompanied the end of the Civil War, had decided the previous year to stop writing. He argued that because he was a technically qualified land engineer, he was unable in the present situation 'to engage in contemplative work such as literature'!

Towards such defiance of hope without illusions.

When I stopped working the drawing, it looked too undisturbed and too self-centred. Somebody with that kind of defiance would be unlikely to feel at home in a self-portrait. My error had been to overlook this. Platonov, it's true, was more immediately present in the sketchbook than in the photograph. But he had an urgent appointment to keep elsewhere.

What to do?

Next day, I was rummaging in my shoulder bag to find my mobile telephone because I wanted to send a text message, and I came upon a railway ticket for a journey in a TGV which I had made a week earlier. From Geneva to Paris. This train's speed, when running at its fastest, is around 300 kilometres per hour. The maximum speed of the trains which cross and re-cross and cross again Platonov's stories was less than 100 kilometres per hour.

On the back of the ticket I had written notes for a speech I was to give at a political meeting. There was a reference to Simone Weil, who died nine years before Platonov, and a quotation from César Vallejo, who died thirteen years before. All three struggled

for the same cause. My notes were practically illegible because the ticket had got wet and the ink had run when I was walking in the rain the next day.

When I later picked up the sketchbook with the portrait of Platonov I remembered the ticket. And for the hell of it I placed it at the bottom on the drawing. It seemed to offer the disturbance that was being asked for.

The disturbance of distances. A disturbance that can only be accommodated if one takes an 'aerial' view in which kilometres become millimetres, yet in which the size of our human hearts is not reduced.

Platonov was a master of such distances. In 1946 he published a story about a soldier from the Red Army returning home after years of absence. In this story Distance and Intimacy sit very close together.

'Ivanov went up to his wife, put his arms round her and stood there with her, not moving away, feeling the forgotten and familiar warmth of someone he loved . . .

'While he sat there the whole family bustled about in the living room and in the kitchen, preparing a celebration meal. Ivanov examined, one after another, all the objects around the house – the clock, the crockery cupboard, the wall thermometer, the chairs, the flowers on the window sills, the Russian kitchen stove. They had lived here a long time without him, and they had missed him. Now he had come back and he was looking at them, getting to know each one of them again, as if they were relatives whose lives had been poor and lonely without him. He breathed in the familiar, unchanging smell of the house – smouldering wood, warmth from his children's bodies, a burning smell from the grate. This smell had been just the same four years ago, it had not dispersed

or changed in his absence. Nowhere else had Ivanov ever smelt this smell, although in the course of the war he had been in several countries and hundreds of homes; the smells there had been different, always lacking the special quality of his own home. Ivanov also recalled the smell of Masha, the scent of her hair, but that had been a smell of leaves in a forest, of some overgrown path he did not know, a smell not of home but once again of unsettled life.'

I glued the railway ticket to the drawn portrait. Andrei Platonov thus seemed to be present.

The imaginative movement which prompts the impulse to draw – whatever the subject may be – repeats implicitly the same pattern that the story of Platonov's portrait illustrates explicitly.

There is a symbiotic desire to get closer and closer, to enter the self of what is being drawn, and, simultaneously, there is the foreknowledge of immanent distance. Such drawings aspire to be both a secret rendezvous and an au revoir! Alternately and ad infinitum.

Whatever the mind understands under a species of eternity, it does not understand owing to the fact that it conceives the actual present existence of the body, but owing to the fact that it conceives the essence of the body under a species of eternity.

(*Ethics*, Part V, Proposition 29)

Now I can make it simpler. There are photos of the American folk singer Woody Guthrie in which his look, the expression of his eyes, resembles Platonov's. They had other things in common. Both lent their voices to those without a voice, and both confronted dire rural poverty. Guthrie's principal subject matter was what the Great Depression and the Dust Bowl droughts of the 1930s did to small farmers in Texas, Oklahoma or the Dakotas. How they lost their mortgaged homes, had to take to the road with their bundles, jump on freight trains or trek, and somehow make it to California where they believed there was work.

Guthrie was a charismatic performer and guitar player and a natural improviser. He sang old songs, and he sang many new songs written by himself to old tunes. One of these is entitled 'So Long, It's Been Good to Know You'. He puts these words into the mouths of the thousands who had to take to the road from the city of Pampa on the west Texan plain during the Depression.

On the radio I heard recently a recording of him singing this song, whose refrain he had changed to: 'Hold on, hold on, it's been good to know you'. Or so I thought. Perhaps I misheard. No matter. Like this, it's a refrain which addresses the subject of any drawing which has insisted upon being put on paper.

'Hold on, hold on, it's been good to know you'.

Melina, my granddaughter, asked if she could draw in the sketchbook. I hand it to her, and she sits at the table, bent forward in concentration. I leave her there. Later she shows me the finished drawing.

You see?

Tell me, I say.

Can't you see? Two eyes.

I thought they were necklaces.

Why then should there be two? Two eyes. First, I drew one, and then I had to do the second.

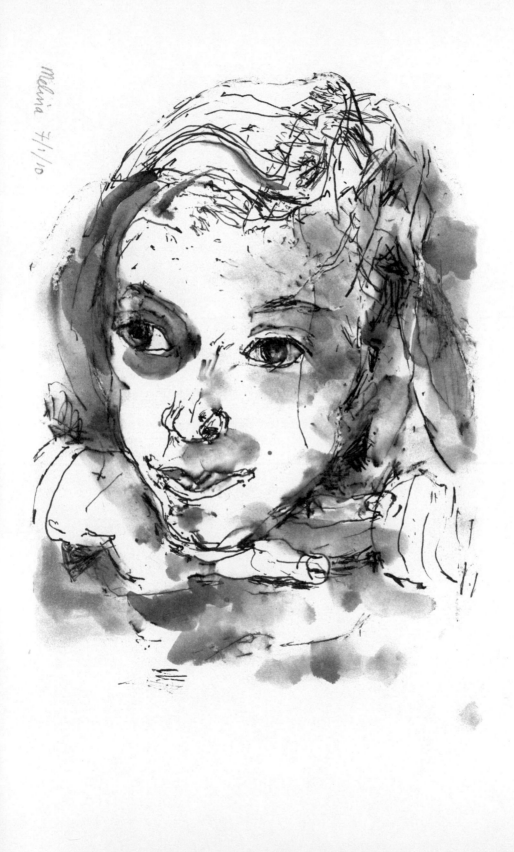

Melina 7/1/10

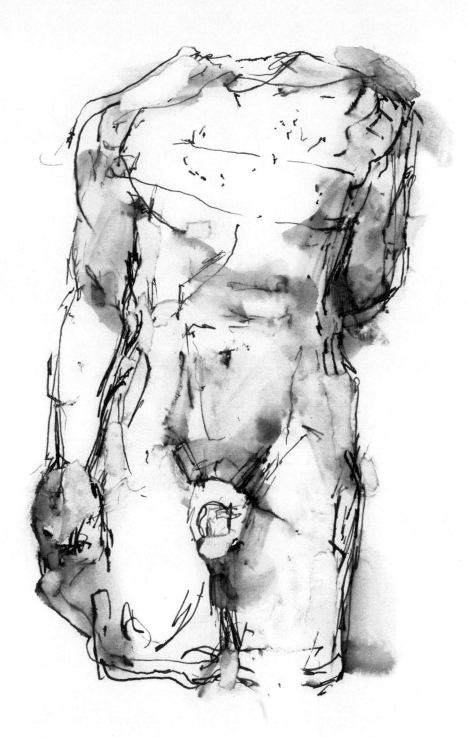

Kouros. 600 B.C.

A BIOGRAPHICAL NOTE

Baruch or Benedict Spinoza was born in Amsterdam on November 24, 1632. His parents, Jewish immigrants from Portugal, were well-off merchants. Rembrandt lived a few streets away from their home. At the Jewish High School Benedict studied the Talmud and Torah and the Old Testament. He was a precocious and brilliant scholar, but for all his brilliance he failed to show respect to some of the rabbis and set a bad example. The authorities tried to silence and accommodate him by offering him a stipend. He turned it down, as he turned down all offers of patronage throughout his life. There was, one day outside the synagogue, an attempt to make cold meat of him, but it failed. Finally, when he was twenty-four, he was definitively banished and excommunicated from the Jewish community. The words of the *cherem* pronounced against him by the synagogue declared that: 'The Lord shall destroy his name under the sun and cut him off for his

undoing from all the tribes of Israel, with all the curses of the firmament which are written in the book of the law.'

During the next twenty years, until his early death at the age of forty-four, he read and thought, he explained and contested Descartes, he made notes, he reflected, he wrote with the most sustained energy, yet, as it were, anonymously. He wrote about freedom as few others have done. He corresponded with scientists, he met and discussed with friends. But he wrote his books in Latin, which was not an easy language for him. And he refused to publish them in his lifetime. He addressed posterity. He lived – in whichever town it was – in two or three modest rooms. The only family inheritance he demanded was his parents' four-poster bed. He was fascinated by optics. He drew. He apparently drew a self-portrait in which he is disguised as the Neapolitan fisherman revolutionary Masaniello, who had become a legend when Spinoza was fifteen. He smoked a pipe. He polished lenses to make a living. And he lived surrounded by friends who were sustained by his calm, his frugality, his cheerful humour, his pertinence and his manner of being adequate.

'I do not presume', he wrote in a letter, 'to have discovered the best philosophy, but I know that I understand the true one.'

ACKNOWLEDGEMENTS

This work would never have existed without the help, encouragement and support of a number of people whom we'd like to name.

First, Beverly, to whom our sketchbook is dedicated.

Also: Alex, Anne, Arundhati, Bernard, Bob, Claude, Colin, Colum, Ellen, Emmanuel, Fatiah, Gareth, Hans, Isabelle, Jean-Michel, John, Joschi, Katya, Sister Lucia, Maria, Melina, Michael, Michel, Nella, Nuria, Pierre, Pilar, Ramon, Rema, Robert, Rostia, Sandra, Sarah, Simon, Tilda, Tom and Yves.

Thank you.

Pages 9 to 16 were first published in the February 2010 issue of *Harper's* magazine, and pages 118 to 128 in the September 2010 issue of *Harper's*. I would like to thank the *Harper's* editors Ellen Rosenbush and Roger O. Hodge for this.

The quotations from Spinoza are taken from *Ethics* and *Treatise on the Correction of the Intellect* in the edition translated and edited by Andrew Boyle and G. H. R. Parkinson (J.M. Dent, London, 1910; revised edn, 1993).